Hiroshi Suzuki

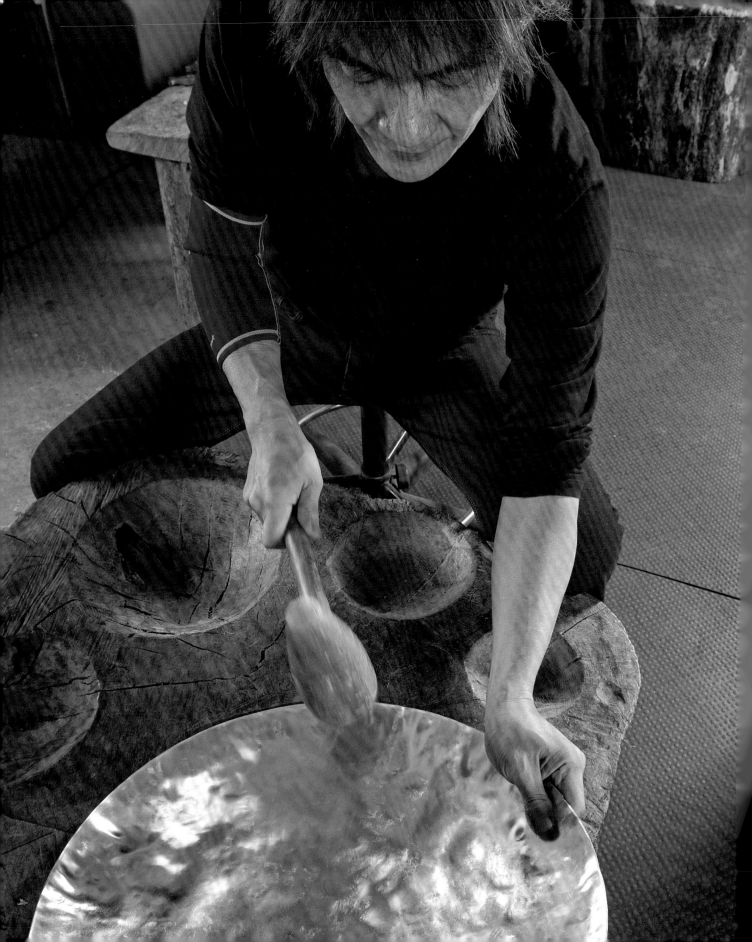

Hiroshi Suzuki

Scala Publishers Ltd
in association with Adrian Sassoon, London

Foreword

Rupert Hambro, Prime Warden of the Goldsmiths' Company

This book has been produced to coincide with *Hiroshi Suzuki – Silver Waves*, a retrospective exhibition held at Goldsmiths' Hall in London in the spring of 2010. The Goldsmiths' Company is delighted to host this exhibition and is most grateful to Adrian Sassoon, Suzuki's principal dealer, and Scala Publishers for publishing this beautiful record of Hiroshi Suzuki's work.

As an ancient City livery company, the Worshipful Company of Goldsmiths has many roles, but its most important is to promote the craft and industry of the goldsmith, silversmith and jeweller. During Suzuki's 15 years' residence in this country the Company has had a number of opportunities to support his unfolding talent. He has been prominently featured in several exhibitions held at Goldsmiths' Hall, most notably *Celebration in Gold and Silver* in 2003 and *Creation* in the following year.

The Company has also acquired four significant works for its permanent collection: an *Aqua-Poesy V* vase and *Dual-Rivulet VII* bowl (both in 2001), an *Aqua-Poesy VII* vase (in 2003) and a fourth piece, *Ayawind II* vase (in 2005). This last piece was exhibited in London at the Crafts Council in 2005, when Suzuki was shortlisted for the Jerwood Applied Arts Prize. In addition, nearly all his works in gold and silver – those included in the exhibition as well as others now belonging to private and public collections around the world – have been hallmarked at the London assay office in Goldsmiths' Hall, where hallmarking has been practised continually for 700 years.

As a Japanese craftsman working in England, Hiroshi Suzuki is unusual. But there is a long tradition of foreign craftsmen migrating to this country. Sometimes this was for economic reasons but more often it was because religious differences had made it impossible for them to continue living in their own country. Most famously, Louis XIV's persecution of French Huguenots (Protestants) in the late seventeenth century led to the arrival here of large numbers of refugee goldsmiths. It has always been recognised that this immigration brought with it new skills and ideas that did much to enrich the artistic standards of work in this country. Hiroshi Suzuki stands squarely in this tradition and as he embarks on a more international role, dividing his time between the UK and Japan, we wish him well and celebrate the remarkable contribution he has made to the art of the silversmith in England.

Hiroshi Suzuki in England

Timothy Schroder

Hiroshi Suzuki (b. 1961) has a boyish smile that sits engagingly with his shock of slightly greying hair. He also has a tendency to say the unexpected, although these remarks are seldom unconsidered. One such remark was when I visited him in his Croydon workshop last August: 'I do not really think of myself as a silversmith, but silver is my medium and it is what allows me to express my creativity. I am attracted to it because of its fluidity.' It is this sense of fluidity more than anything else that is so striking in the work of Hiroshi Suzuki. The metal seems to have a motion of its own, frozen but alive. But it is this very quality that makes his work difficult to define or to place in the context of today's silversmithing scene or the larger traditions of European or Japanese metalworking.

His work is full of paradoxes. It has a narrow range of forms, but is endlessly varied; it is amorphous but instantly recognisable; it stands outside almost every tradition, yet is full of resonances, bridging European and Japanese aesthetics, as well as different media, such as pottery, glass and the traditional materials of sculpture.

Alluringly original though Suzuki's work is, it has grown from seeds that were planted in his early life and germinated by his almost chance arrival in England in 1994 at the age of 33. He was born in Sendai, about 240 miles north of Tokyo, and he came from an artistic family. His father, Hisao, was a skilful goldsmith and his grandfather, Takeo, a potter and calligrapher. At home there was a workshop, which he loved to explore, playing with his grandfather's clay. He speaks of a solitary childhood, saying 'my parents and teachers at junior school worried that I wasn't making friends. It wasn't that I did not like playing with other kids; it is just that I was more interested in playing with materials.'

This love of manual expression and his family background made it natural that he should go to art school and in 1982 he started a four-year three-dimensional design course at Musashino Art University in Tokyo. At that stage Suzuki thought his career would lie in the field of industrial design, a direction that the strict curriculum at Musashino encouraged. But it was not to be and his career followed a different path. He stayed on at college, going on to take a two-year MA course after finishing his BA in 1986. This was not the end of his association with Musashino and the MA course was followed by a period of employment at the college as a technical assistant. This provided him with an income, as well as giving him access to the college's workshops, where he could work on his own, exploring artistic ideas in his own time. It was in many ways an ideal opportunity for a young man with artistic aspirations but as yet no clear idea of the exact path he wanted to follow. But his contract was for only five years and in 1993 he was once more without a job.

He decided to use the opportunity to travel to England and take stock. He wanted to learn English and he planned to use his time exploring museums and familiarising himself with European artistic traditions. But, never content to do nothing, he decided in 1994 to further his formal education and enrolled in the Camberwell College of Arts for three years, followed by an MA at the Royal College of Art (RCA) from 1997 to 1999.

Suzuki speaks of an atmosphere in the English art schools that was entirely different and in many ways more liberating than that in Japan. At Camberwell the tutors fostered a freedom of approach that encouraged students to find their own way and their own strengths rather than following a rigid syllabus. Both systems have their strengths and their weaknesses. The Japanese is more technically grounded. In the first two years students are taught to draw and learn basic techniques. Only in the last two years are they allowed to develop their own ideas. The English system, by contrast, gives much freer rein from the start, although this can result in creative ideas that are not always supported by a proper grounding in practical skills.

Pressed on the influences during his student days in England, Suzuki singles out Michael Rowe, a sculptor in metalwork, and the Danish silversmith, Allan Scharff, both of whom taught him at the RCA. Rowe first awakened Suzuki to the possibility of working in silver. But his work could hardly be more removed from what Suzuki's was to become and his vessels have a distinctive, uncompromisingly geometric quality. By contrast, Scharff's influence was much more direct. Trained in the Georg Jensen workshops in Copenhagen, Scharff rejoices in the ductility of silver. His work has an organic, flowing quality that was a clear source of inspiration to his pupil. His master class in silversmithing was an experience that Suzuki describes as if it were a Road to Damascus conversion. Still harbouring thoughts at this stage of becoming a sculptor, Suzuki was not sure at first if this would be the right direction for him. But he soon found otherwise, saying emphatically that 'working with Allan for just a couple of weeks was the turning point of my life'.

After finishing at the RCA in 1999, Suzuki took space for a while at a workshop run by some of his former Camberwell classmates. He was by now already coming to the notice of a wider public. The RCA had chosen one of his early silver vessels for its permanent collection (page 17) but the Victoria and Albert Museum's 1999 purchase of a large *Aqua-Poesy IV* vase and the Birmingham Museum and Art Gallery's the following year of the *Figure Δ* vase were important mileposts in his career. His first major selling exhibition was the group show *A Feast of Silver* at Contemporary Applied Arts in London in 2000. He also received support from the P&O Makower Trust, but equally important for his international profile was receiving the grand prize at the 1999 Cheongju International Craft Competition in Korea, triumphing over 1,047 entries from 13 different countries.

A problem with his UK visa forced Suzuki to return to Japan for nine months in 2001. But by the following spring he was back in England, taking up a residency at the School of Jewellery at the University of Central England in Birmingham. Shortly afterwards he was offered a workshop of his own at the Harley Foundation on the Welbeck Estate in Nottinghamshire, where he worked until spring 2009 and where he has done nearly all his significant work.

Suzuki's working method is most unusual. Traditionally the silversmith's creative process would start with a sketch or a *modello*, either to show to a patron or to work out design issues for himself.

Sculptors would usually start in a similar way, developing their ideas on paper or modelling in clay or plasticine before turning to the more difficult and costly full-size stone or bronze of the finished work. Suzuki completely rejects this process. For him the act of creation is in the actual making. 'I take the material directly and just start making and designing through the making – it's really risky but to me it's a more enjoyable process… For me, drawing is not just developing the idea; the drawing itself is the final presence. For this reason I don't like to draw first and afterwards to make, because once I make a drawing, my role in the process is over. I don't need to make it myself any more.'

There is a sense of freedom and spontaneity to this that is expressed in his working of the metal itself. The ductility of silver depends partly on the fineness of its alloy. His first works were in Britannia silver, which, being 95.8% pure, is significantly softer and more malleable than sterling (92.5%). But quite soon he had opted instead for 'fine' silver, virtually pure and unalloyed, which is the softest and most ductile of all. It perfectly suits his manner of working, in which his vessels are freely formed, 'over air', so to speak, rather than by means of raising stakes. Only for the final chasing stages does he fill the vessel with pitch to act as a foil to his steady, rhythmic hammering.

Watching Suzuki work is mesmeric. Hammering is the beginning and the end of his work, but, when he speaks of it, it becomes clear that it is much more than a mechanical process. Like a pianist's fingers, it is an extension of his mind: 'Rhythmic hammering normally brings with it a meditative quality. It's quite a simple rhythm, just bam-bam-bam, just repeat, repeat, repeat. But I try to get into a meditative state, and imagine something nice. That's very important and unless I make my feelings creative it's just a very long process. The hammering is very, very important for me.'

Assessing Hiroshi Suzuki's work since he came to this country is not easy and its abstract quality makes it difficult to discuss in concrete terms. His early 'English' works were in 'gilding metal', a soft and malleable copper alloy that can take a variety of patinations (page 16). These were loosely conceived, amorphous forms but already it was the vase idea that predominated and already there was a strong sense of shape and surface having a sort of organic unity.

His first works in silver are extraordinary. *Seductions* (page 17), an open-mouthed vessel of 1998, seems to recall anything from a burst seed pod to pre-Columbian pottery but has a sort of unresolved quality that represents an idea half-formed. His *Figure* series of around 2000 (page 19) shows a masterly command of raising and an astonishing ability to move metal around, but, ultimately, these vessels are more appealing as technical tours de force than as works of art.

With his adoption of fine silver (and later gold too) as his chosen material came a new focus on a particular series of themes that he has continued to explore ever since. His repertoire includes bowls and beakers, but his 'signature form' is undoubtedly vases. These fall into several 'families' corresponding – though loosely – to the ancient four

elements (earth, air, fire and water) and are called *Earth-Reki*, *Ayawind*, *Miyabi-Fire* (literally 'noble fire') and *Aqua-Poesy*.

These broad families subdivide into groups of different shapes that he has numbered as they have developed – *Aqua-Poesy VII*, *Earth-Reki II* and so on. The *Aqua-Poesy VII* vases, for example, are essentially spirally conceived and articulated in relief with ridges and furrows that seem to suggest flowing or rippling water. The *Miyabi-Fire* series has patterns of rising flame-like relief, while the *Earth-Reki* vases have a more robust pattern of ridges that recall the rough symmetry of ploughed soil. But the differences between these groups are not rigid and he admits that 'with some pieces I don't know which way they will come out until the end. It is always experimental.'

Essentially the inspiration for all the vase types is the same: 'I'm interested in fluid movements. Sometimes these came from the idea of water, sometimes from fire and sometimes from the ground.' The vase form itself he describes as 'my canvas', saying that its 'limited form' nevertheless provides scope 'for a lot of different expression and different kinds of treatment'. But there was a practical, commercial, aspect to his adoption of the vase too. Suzuki shrewdly acknowledges that 'the vase form is accessible to many people, whereas if I make a sculptural form, some people will love it but some people will never be interested. Vases, I think, appeal to almost everyone.'

Within these broad family groups, however, there is an extraordinary range of moods. Superficially the 2003 *Aqua-Poesy VII* vase in the Goldsmiths' Company collection (page 25) and another of the same year (page 24) are quite similar. They are of roughly the same profile and proportions and both are embossed in high relief with spiral ridges. But the surfaces are so radically different that they induce completely different responses. The Goldsmiths' vase has an almost white surface that is akin to biscuit porcelain, subtly articulated by burnishing along the crests of the ridges. The other has been very gently polished to reveal a mellow and quietly reflective surface that is altogether softer and warmer. Like the mannered and artificial drapery of medieval or baroque sculpture, these ridges and furrows can be deeply expressive. They are entirely abstract and yet their play with volumes and light, their sense of energy or repose, equilibrium or tension suggests sharply different moods.

A third vase in the same series from 2006 (page 39) has more deeply scooped furrows and higher, sharper ridges. The spiral is tighter and results in a vessel of greater tension and energy. Other more recent vases in the same series (for example, front cover) introduce a secondary pattern of spirals that acts as a sort of contrapuntal voice within the composition as a whole.

But the form of the vessel is only part of its character. An equally important feature is its texture. Indeed, the focus of much of Suzuki's experimentation in recent years has been on surface treatment. The snow-white surface of some of his earlier works, such as *Figure B* (page 19) – a feature that is literally skin-deep and which will probably prove fugitive over time – has given way to a variety of tooled surfaces, which produce entirely

different effects. At first glance these may appear quite simple and similar, but a closer look reveals a fascinating variety, from the softly hammered with burnished highlights to the raspingly abraded (see, for example, pages 34, 35, 59, 60 and 61).

Suzuki admits that 'it is not easy to invent new textures. But I want to continue to explore this field. I think it's a really important part of my work.' It is in these textured surfaces – the last process in any of this works – that he feels a significant difference between his own work and that of many other contemporary silversmiths and it is an area that often presents him with a dilemma: 'Normally craftspeople tend to work for the final presence, the polish and finish, but I don't like that way. So [because my final process involves working into the metal] I find it difficult to judge when is the right time to finish, to do more or to stop.'

In discussing the appeal, as opposed to the appearance, of his work, its abstract nature tends to invite analogy. One such – implied perhaps by his own term, *Aqua-Poesy* – is poetic and was high in the minds of the judges of the prestigious 2009 Schoonhoven Silver Award in their citation of Suzuki's winning entry, *Earth-Reki II* (page 72). In the jury's verdict Suzuki's 'impressive vase is archetypal and combines monumentalism with a refined and poetic feeling for detail and finish'.

Another, equally valid, analogy is musical. His rhythmic hammering as he forms the vessel is itself a music of sorts, but the rhythms retain a presence as patterns in the metal long after the noise of the workshop is forgotten and are one of the real pleasures of handling his vessels. Looking across his work over the last decade the phrase 'variations on a theme' comes to mind and in a sense the vases and bowls of this period amount to long sets of variations, which stand alone as individual works but in some ways read more meaningfully as part of a collective whole.

There is, however, another dimension altogether to Suzuki's work that is absolutely central to his aesthetic but that is invisible, as it were, to the book reader or the museum visitor. A crucial ingredient in the perception of any vessel or small decorative art object, be it glass, porcelain or silver, is its weight and this can only be perceived by taking it in the hand. Weight matters in different ways with different kinds of objects. For a piece of sixteenth-century Venetian glass or certain kinds of eighteenth-century porcelain, lightness may be considered a virtue, because it is a measure of the delicacy of the material. By contrast, good weight in eighteenth-century English glass is a mark of quality because it indicates a high lead content. In silver good weight has always been seen as a sign of quality, because it indicates a higher intrinsic value and because thick-gauge silver is harder to work than thin. By any standards, Suzuki's silver is exceptionally heavy and, by handling it, one is aware of an entirely different – and additional – quality to its visual elements.

No less difficult than discussing his work on its own terms is seeing it in a broader artistic context. Suzuki himself is reticent on contemporary or past artists who have had a direct influence on his work. But he acknowledges being drawn to the work of the

early twentieth-century European sculptor Constantin Brancusi and it is easy to see a general affinity between the abstracted masses of Brancusi's sculptures and his own work. He also mentions the nineteenth-century Japanese artist, Hokusai Katsushika, and the contemporary jeweller, Yasuki Hiramatsu. Katsushika's print *The Great Wave off Kanagawa* (c.1830) is one of the most famous of all Japanese images and Suzuki finds this work particularly inspiring, saying 'I love his work and his way of expressing himself. The waves are so organic, but in a Japanese way, so that they are more like patterns than realistic lines.' Hiramatsu's gold work is on a small scale, but some of his deeply textured surfaces have a strong kinship to those of Suzuki's vessels.

It is perhaps the more general resonances of his work, however, rather than specifically acknowledged 'mentors', that are especially telling. In particular, there is a sense in which his silver – its organic quality, its weight and concentrated density – is akin to contemporary Japanese pottery, whose rough-hewn freedom celebrates the earthiness of the material and retains a sense of the hands of the potter. Suzuki recognises this comparison himself, even enjoying it and saying, 'I think I'm closer to a potter [than to a silversmith]; it's just that I use silver as my main material. I would probably describe my work as ceramics made of silver.'

Other affinities within the decorative arts can be sensed, whether they are actively in his mind or not. These include the glass of the Art Nouveau artist Emile Gallé, which has a weight and concentration that is comparable to Suzuki's silver, or the contemporary American glass artist Dale Chihuly, whose works have a similar organic quality. A more historic comparison that in some ways invites itself is with early seventeenth-century Dutch 'auricular' silver. Invented by the Utrecht silversmiths Adam and Paulus van Vianen and later taken up by the Amsterdam master Johannes Lutma, this has a 'fleshy' quality that is totally abstract, dispenses with all the traditional language of ornament and emphasises the ductile, fluid quality of silver to produce forms and shapes that had never been seen before. The asymmetrical scrolls of eighteenth-century rococo silver and porcelain were perhaps the ultimate heirs of the auricular style and again have a distant echo in Suzuki's work.

These and other 'affinities' that may or may not be detected in his work are interesting but in some ways secondary – and contradictory – to the much more striking impression of his artistic independence. There is one level, however, on which his work is absolutely within a mainstream European artistic tradition and that is in his espousal of the vase form itself. Ever since the Renaissance, European designers have had a love affair with the vase. The fifteenth-century patron Lorenzo de' Medici collected ancient hardstone vases and commissioned elaborate gold and silver mounts to enhance them. Italian artists such as Giulio Romano, Antonio Pollaiuolo and even Michelangelo himself, inspired by ancient marbles excavated in Rome, designed vases or incorporated vase motifs into larger designs.

The vase idea migrated north and became the basis for everything from cups to ewers and candlesticks. Its popularity waxed and waned over the following centuries, but as

a motif it was never far away. The discovery of true porcelain in the early eighteenth century at Meissen led to the creation of magnificent vases inspired by Chinese and Japanese vessels; a little later, at Sèvres in France, artists such as Jean-Claude Duplessis were set to work reinventing the vase in the contemporary rococo idiom. The discovery or publication of now famous ancient vases such as the Portland Vase (in cameo glass) or the Warwick Vase (in marble) played their part in what, by the late eighteenth century, had become nothing less than a mania. The English potter, Josiah Wedgwood, whose jasperware copy of the Portland Vase was one of the most celebrated artefacts of his time, was quick to recognise the commercial potential of vases and wrote in 1769 that 'an epidemical madness reigns for Vases, which must be gratified'.

The variety of these vases is enormous – plain or sculptural, handled or handleless, baroque, rococo or neo-classical and so on – and the vase itself becomes a vehicle for infinite creativity. It is this infinite potential that, two centuries later, Hiroshi Suzuki still continues to exploit and explore, recalling his own modest comment that, through the vase, he can find the way 'for a lot of different expression and different kinds of treatment'.

Modesty is one of the most disarming of Suzuki's qualities. Faced with a difficult question about what his work means for him, he replies: 'I want to show my creative self, what I sense about nature or feel about natural things. I think I want to express that in my objects, but not like a message to society, not like that, not like conceptual art. I just want to show my creativity.' During his time in England that creativity has been channelled into what could be seen as a unique synthesis of Japanese and European sensibilities, with a combination of a Japanese aesthetic and a European love of silver, not for its intrinsic value but for its extraordinary beauty and its special physical qualities.

This exhibition marks the close of an important chapter in Suzuki's creative life and it prompts the question 'What next?' In the 15 years since coming to England he has developed from a totally unknown figure to an artist with an international reputation. His work has been shown and promoted in numerous exhibitions in this country, in Europe and the United States, as well as in his native Japan. It is much in demand from private collectors and can be seen in museum collections in at least half a dozen countries around the world.

And now he stands on the brink of new developments. His recent appointment to a professorship at Musashino Art University in Japan means that he will have less time for creative work and will be able to spend only part of his time in England. What exactly the future holds for his artistic development is not clear. 'My circumstances have completely changed. I'm talking to young students, who have fresh ideas that are really good. So I'm sure I'm going to change my direction. That doesn't mean I will stop hammering, because I really like it, but I do think in the next ten years I will change. Definitely I will start some new work.'

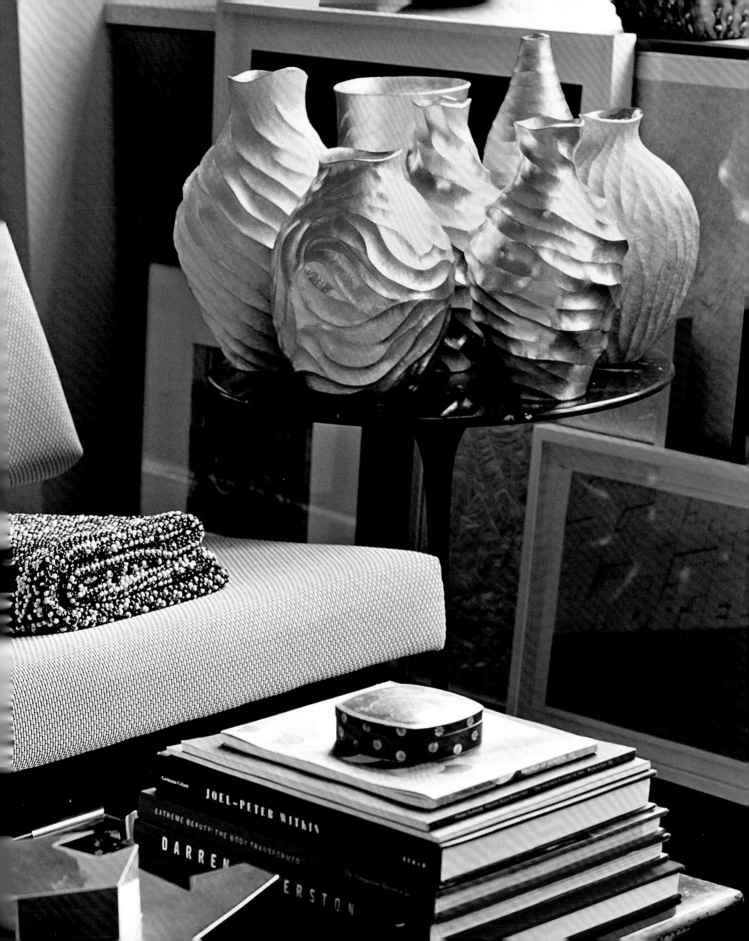

Early Works

page 16

Figure Σ-Sensuality 1996
Hammer-raised patinated gilding metal
H 19.5 cm (7⅝") Ø 16 cm (6¼")
University of the Arts Collection, London, UK

page 17

Seductions 1998
Hammer-raised Britannia silver 958
H 17 cm (6⅝") Ø 15.5 cm (6⅛")
GSM&J Collection, Royal College of Art, London, UK

page 18

Seductions 1999
Hammer-raised patinated copper
H 15 cm (5⅞") W 20 cm (7⅞") D 17.5 cm (6⅞")
Artist's Collection

page 19

Figure B – Venus II 2000
Hammer-raised Fine silver 999
H 25 cm (9⅞") W 21.5 cm (8½") D 15.5 cm (6⅛")
Artist's Collection

page 20

Ka-La II 2004
Hammer-raised Fine silver 999
H 28.5 cm (11¼") Ø 20 cm (7⅞")
Devonshire Collection, Chatsworth, Derbyshire, UK
Reproduced by permission of Chatsworth Settlement Trustees

page 21

Ka-La II 2005
Hammer-raised Fine silver 999
H 24 cm (9½") Ø 24 cm (9½")
Private Collection, UK

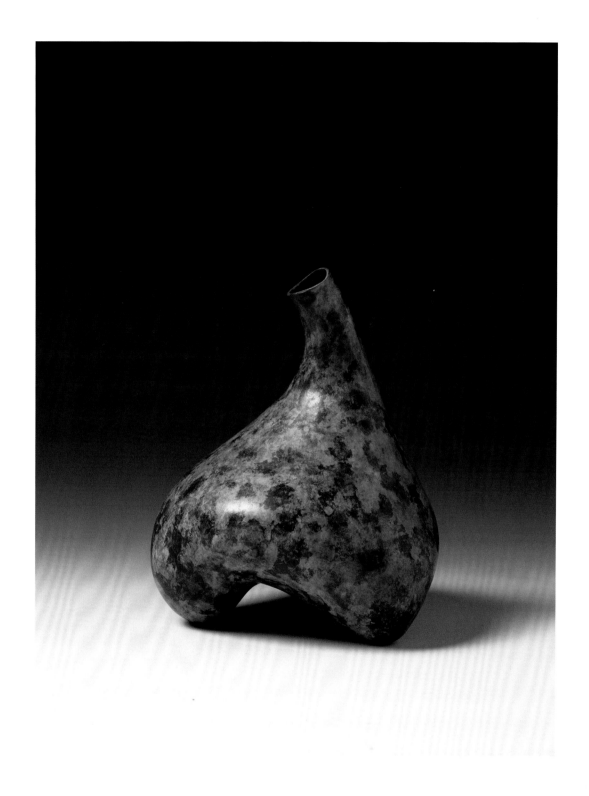

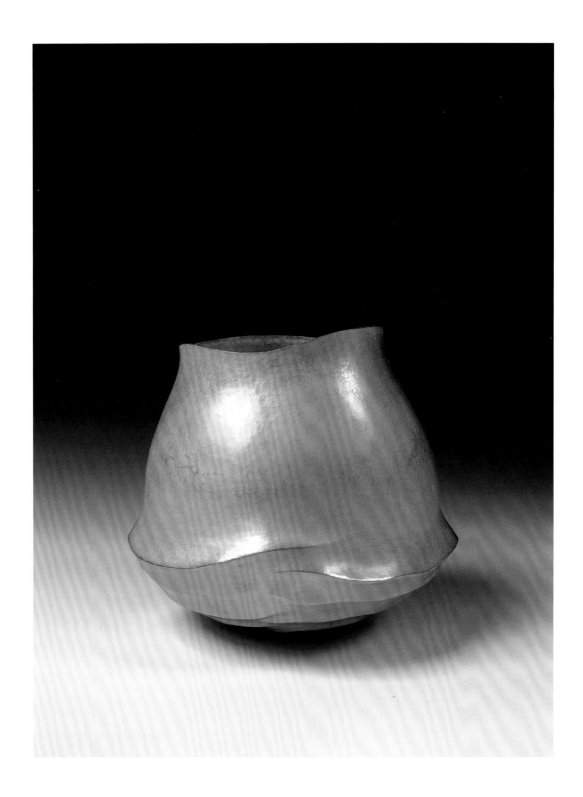

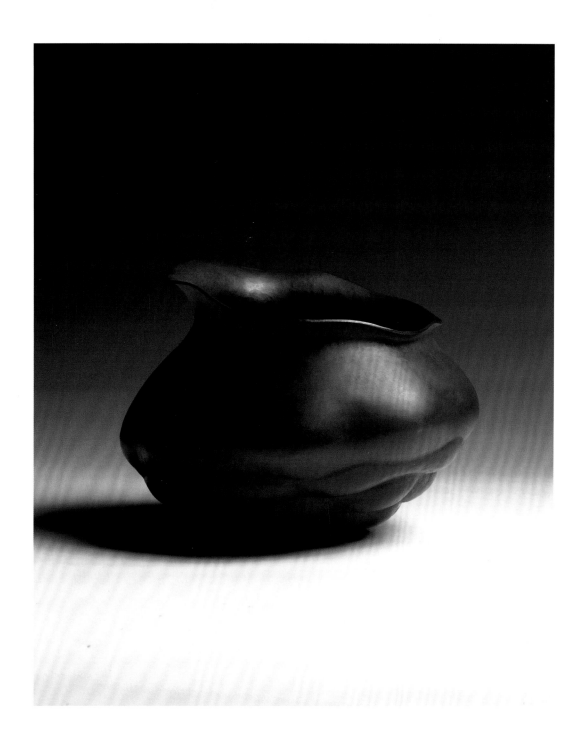

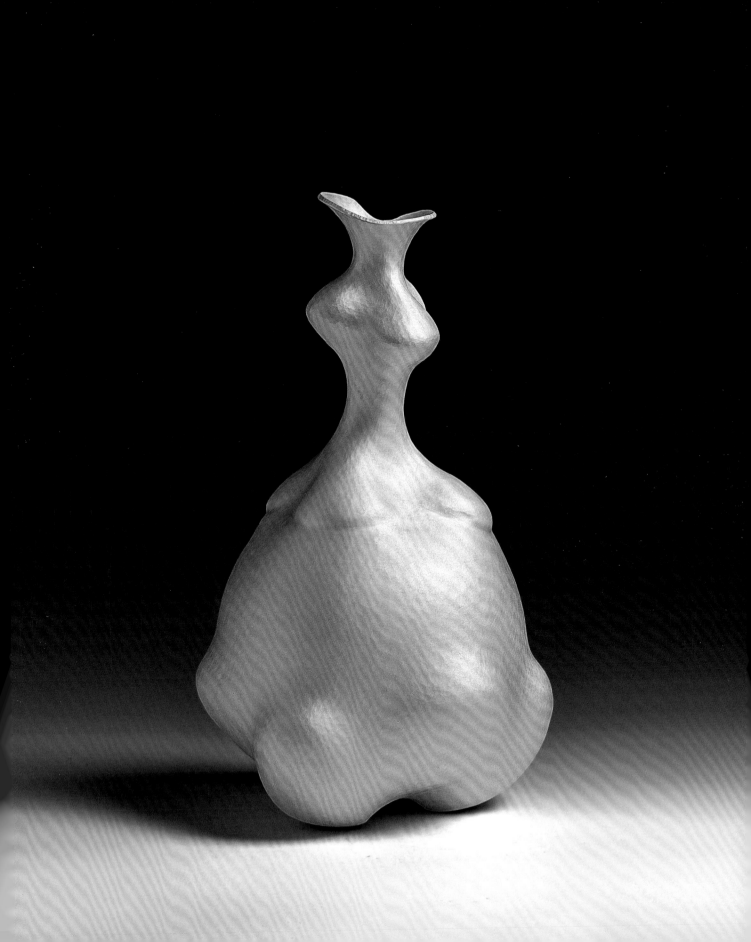

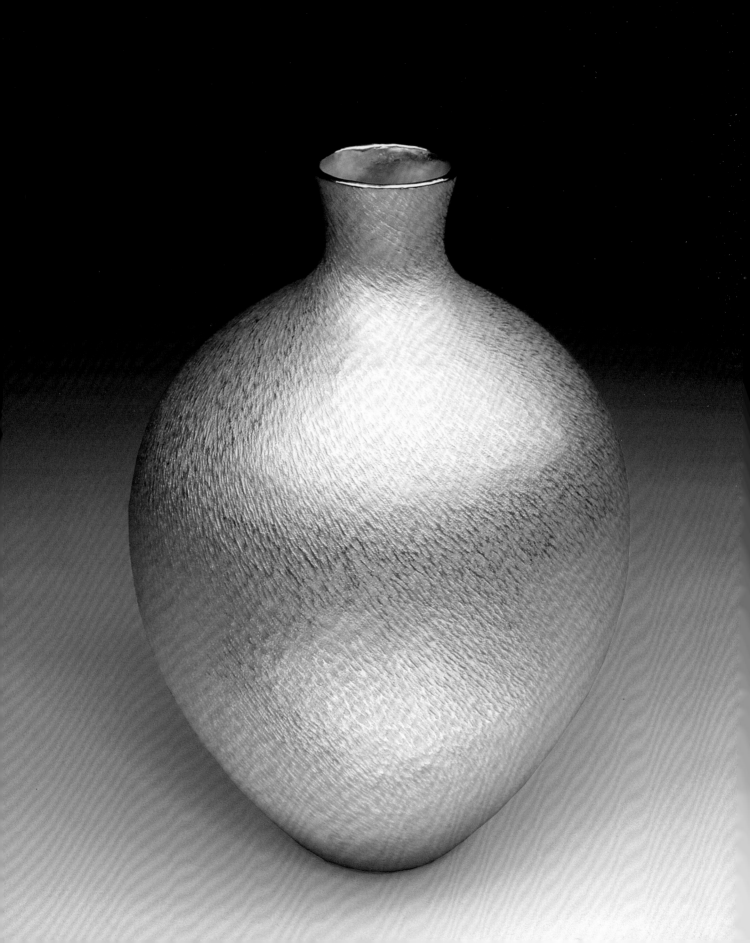

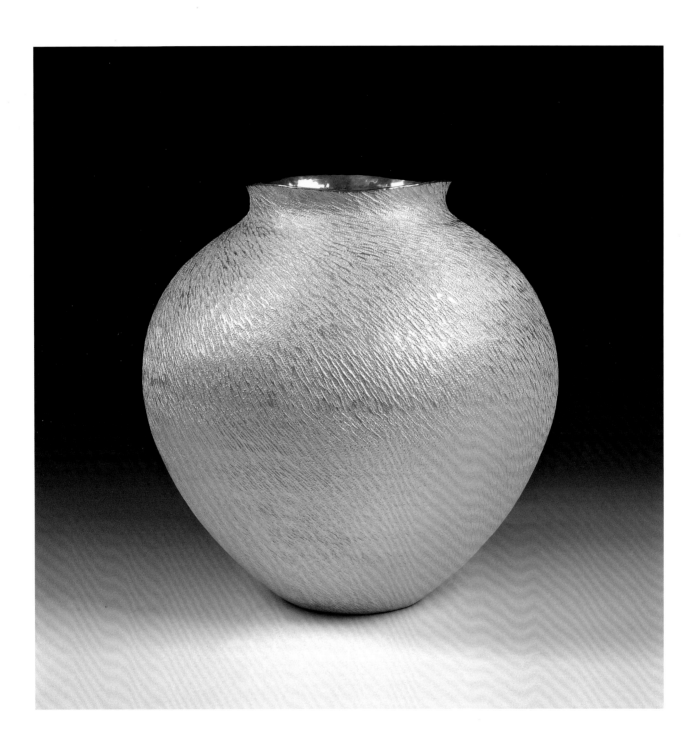

Water

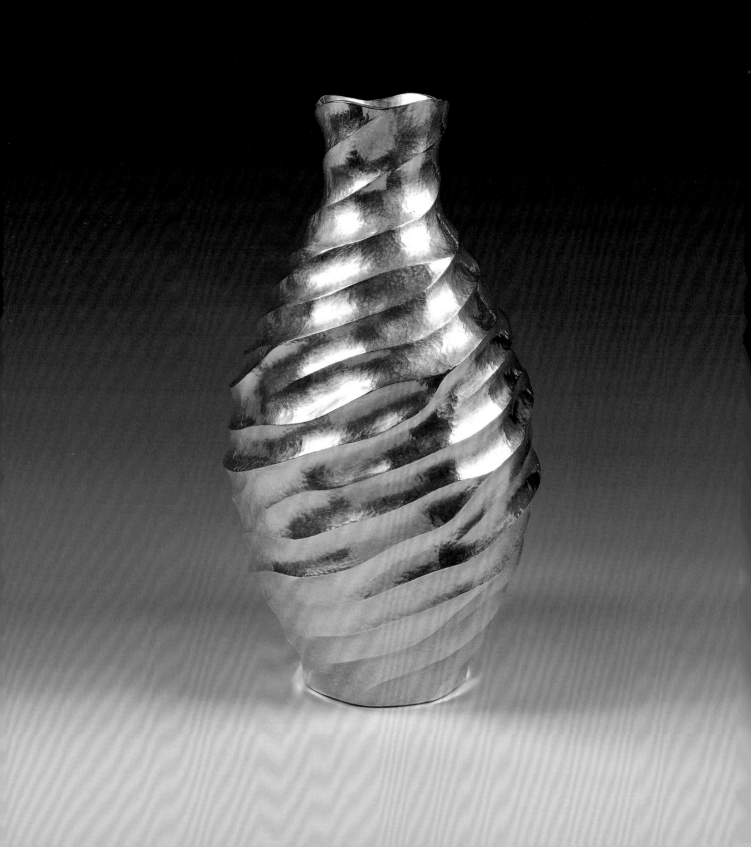

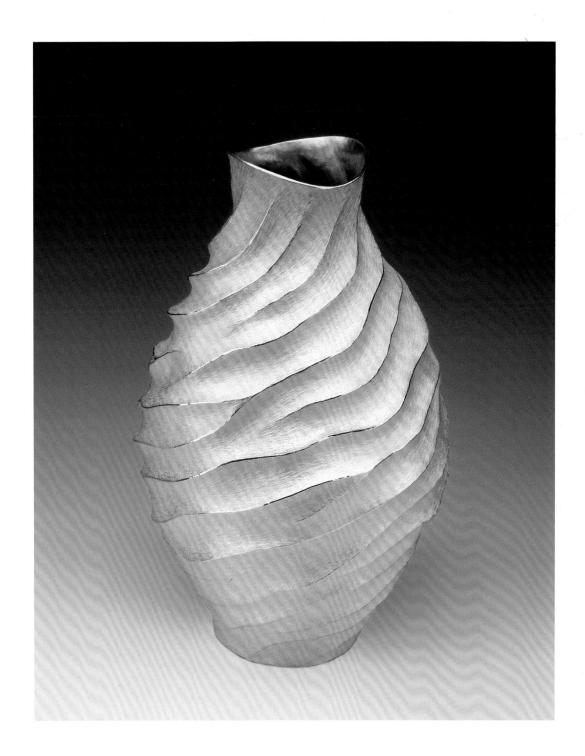

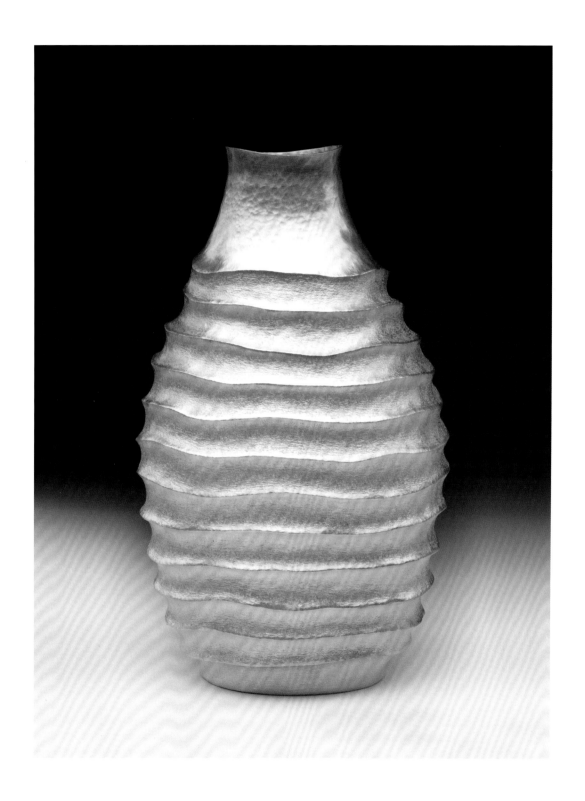

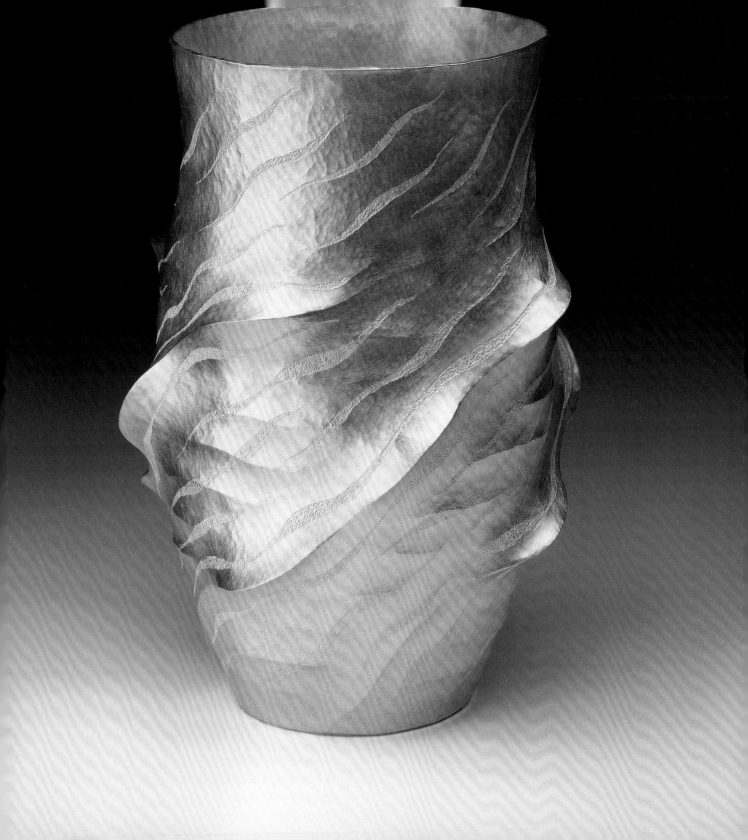

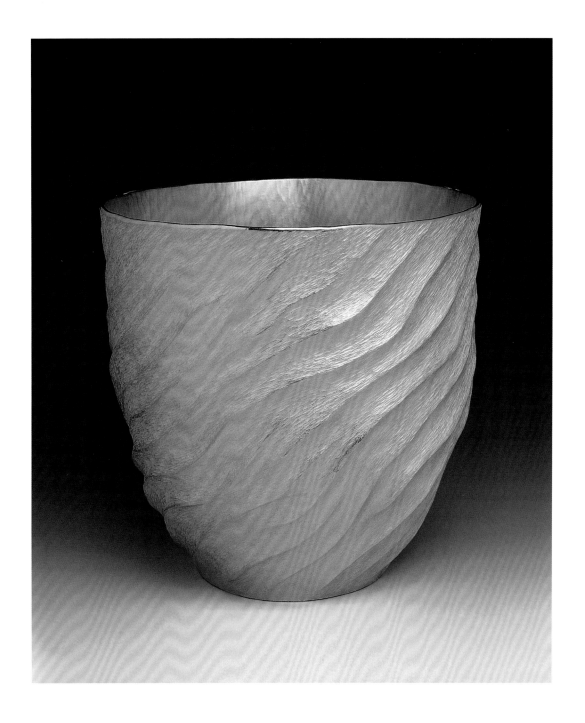

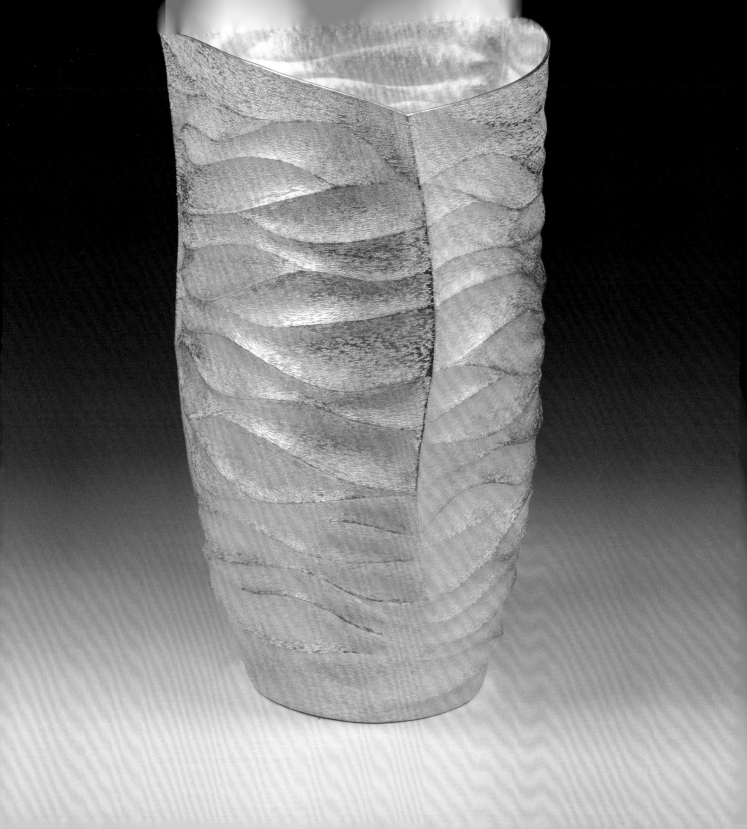

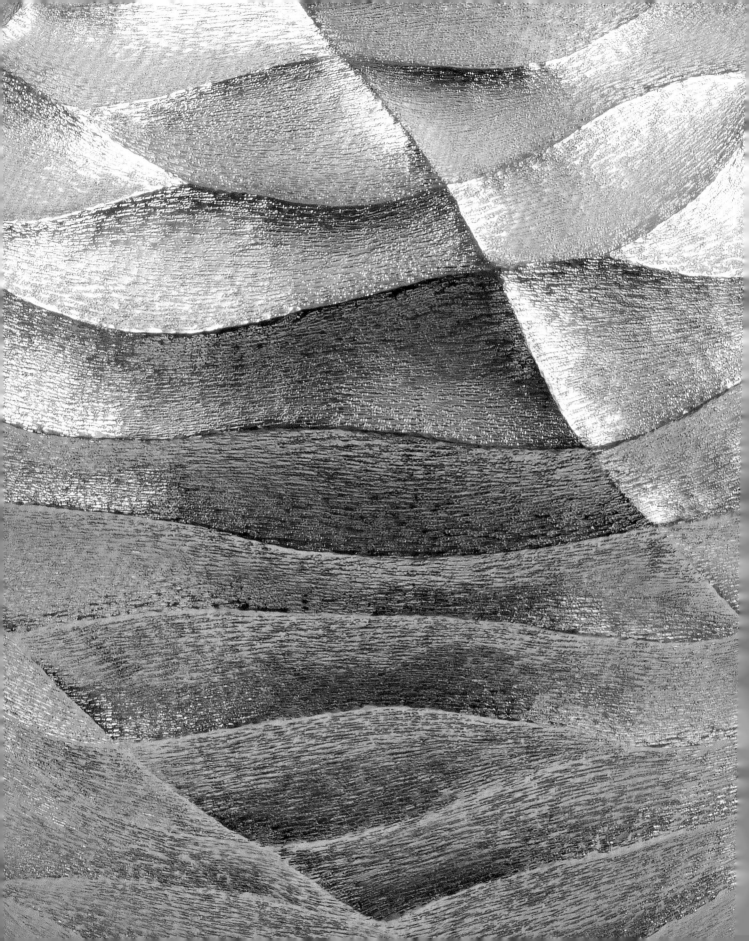

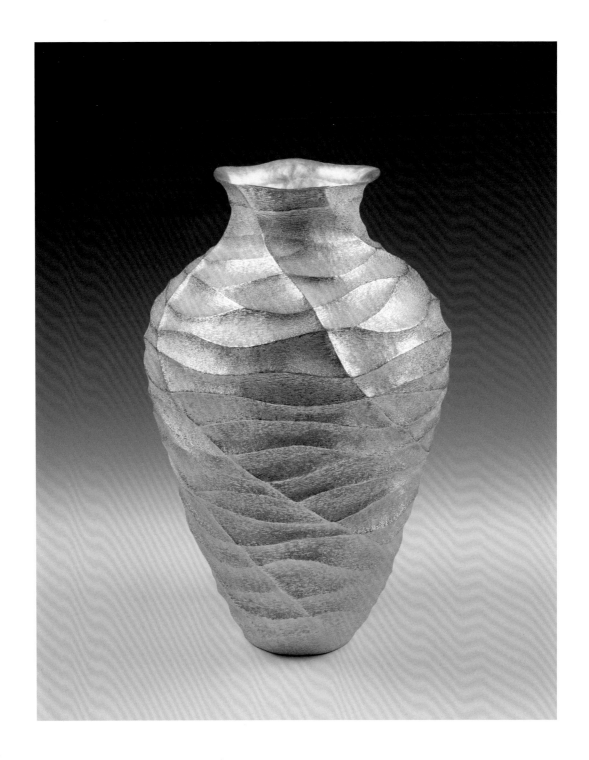

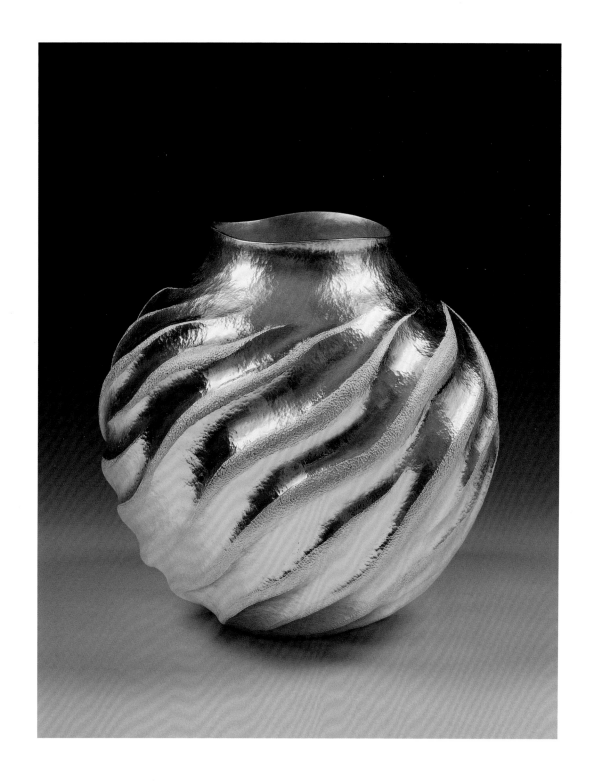

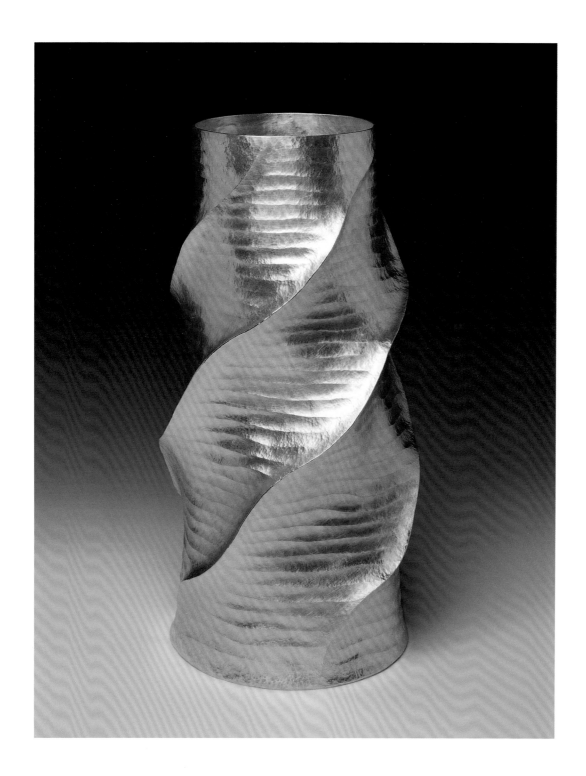

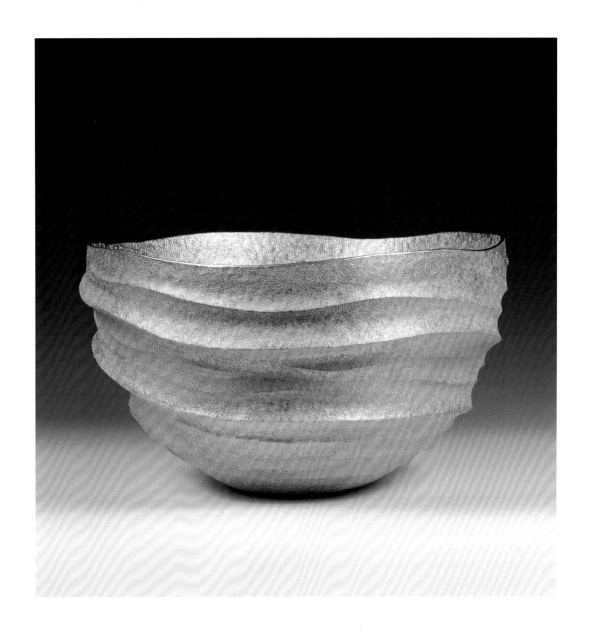

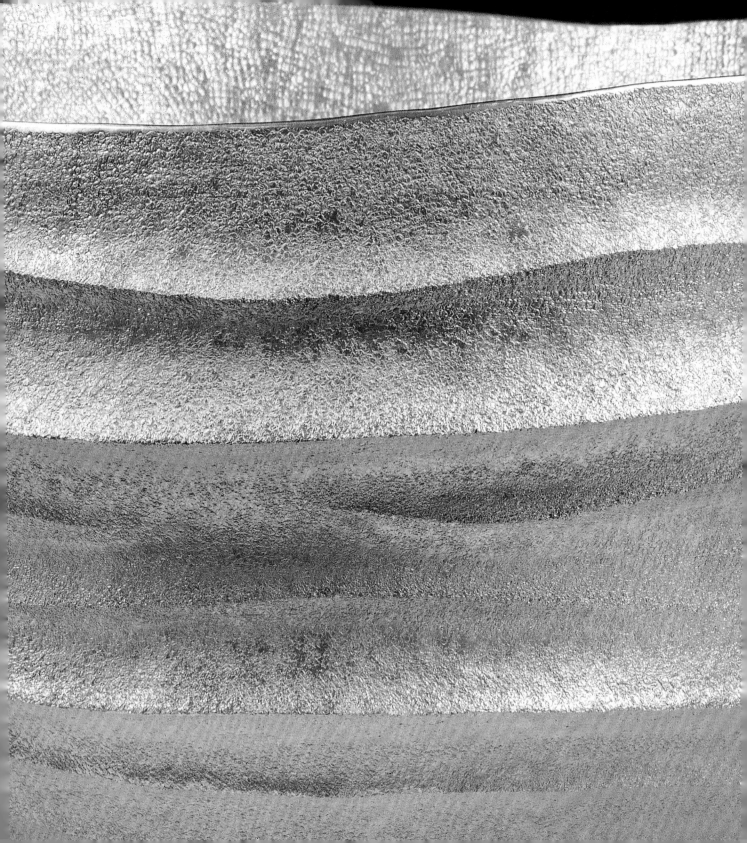

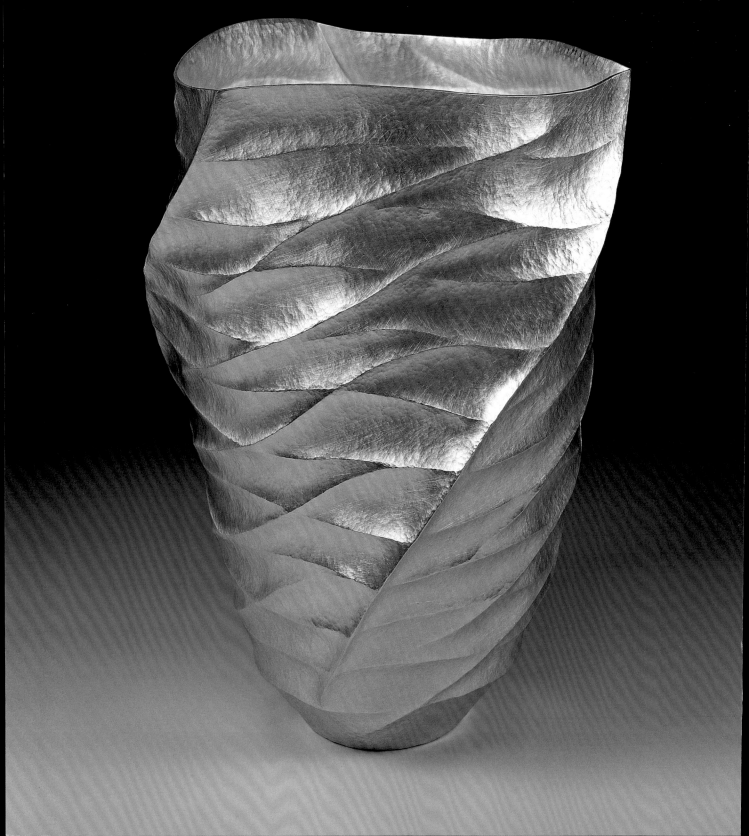

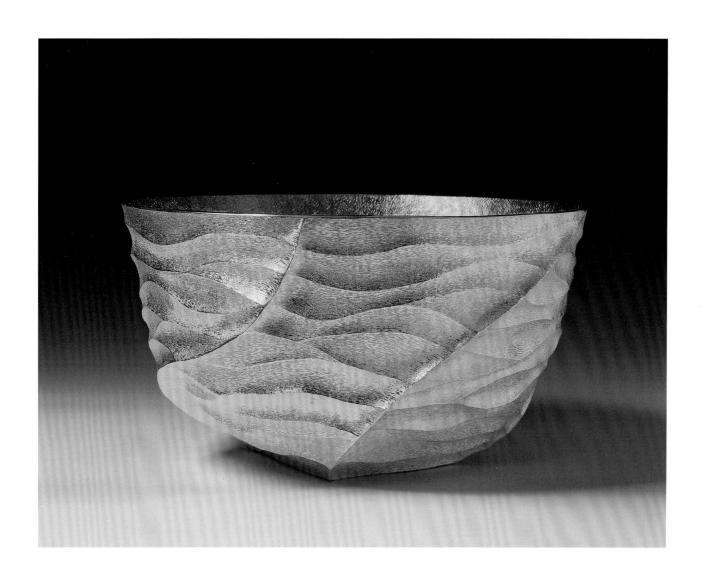

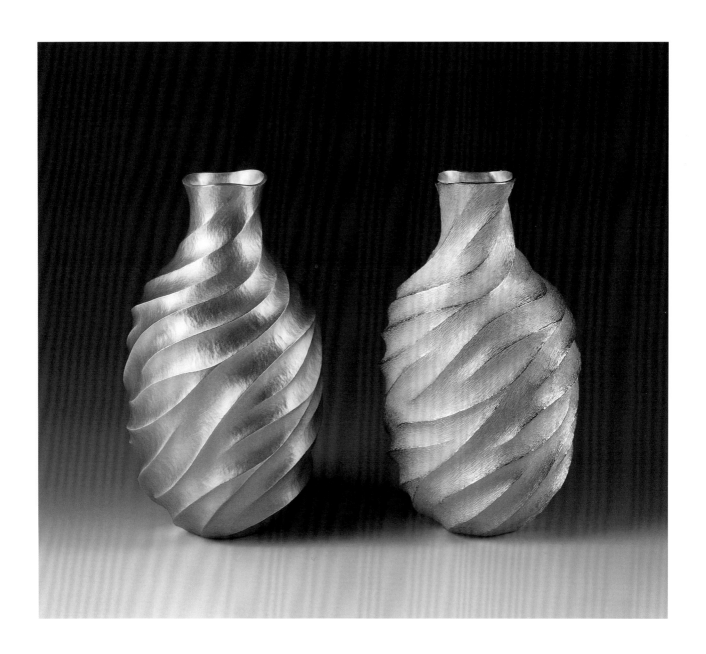

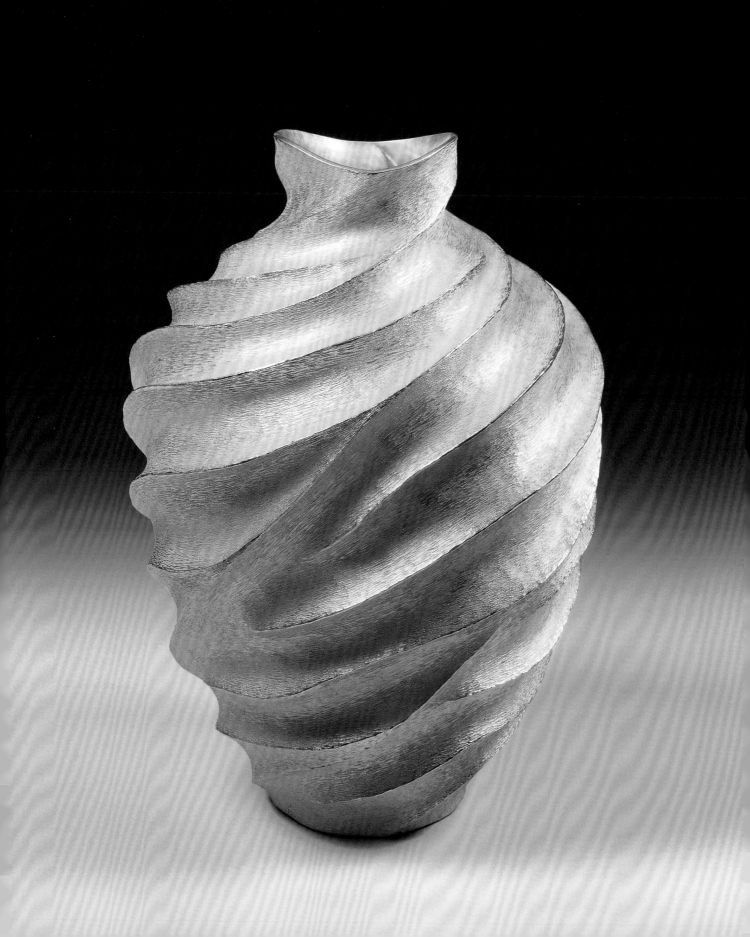

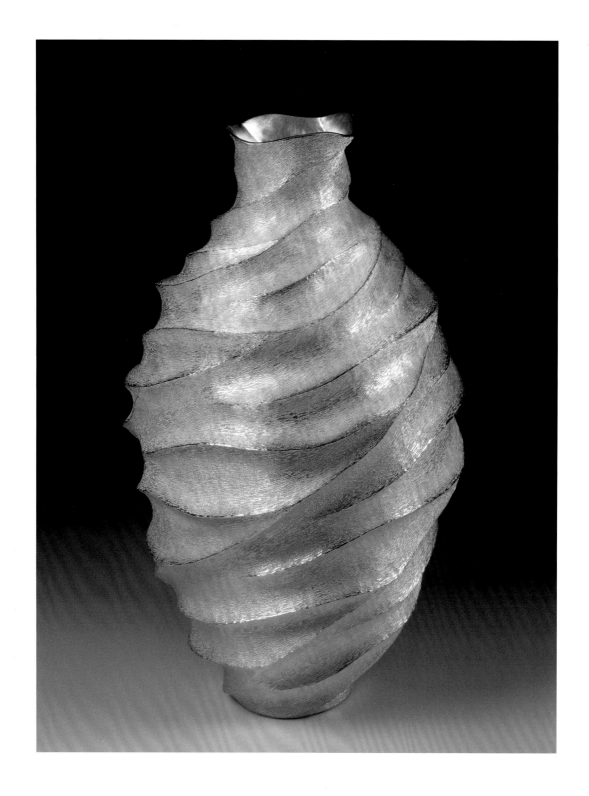

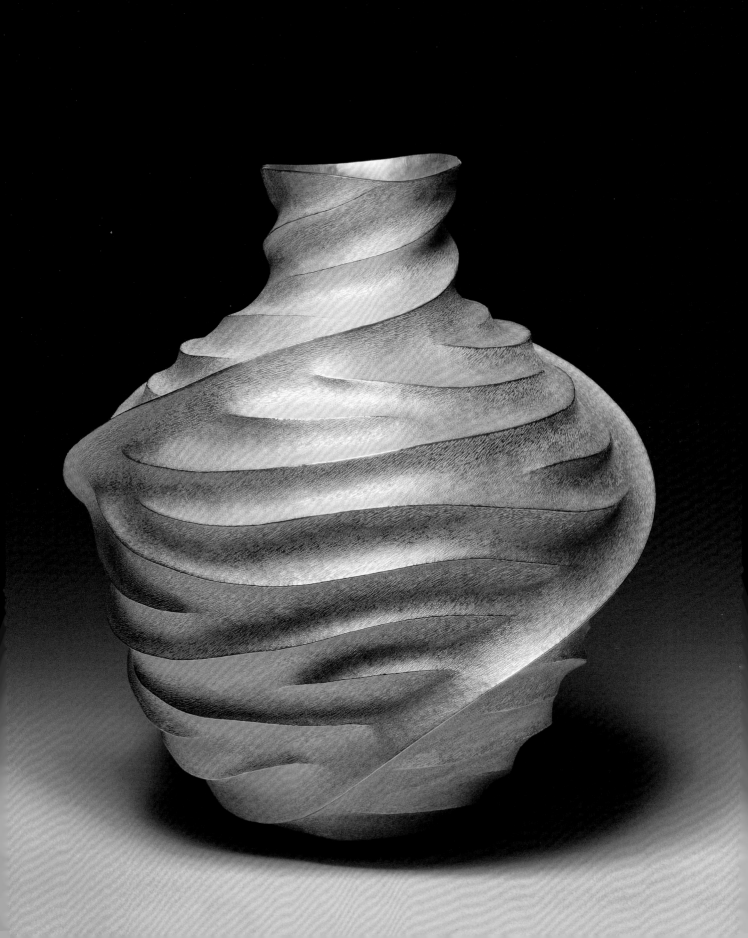

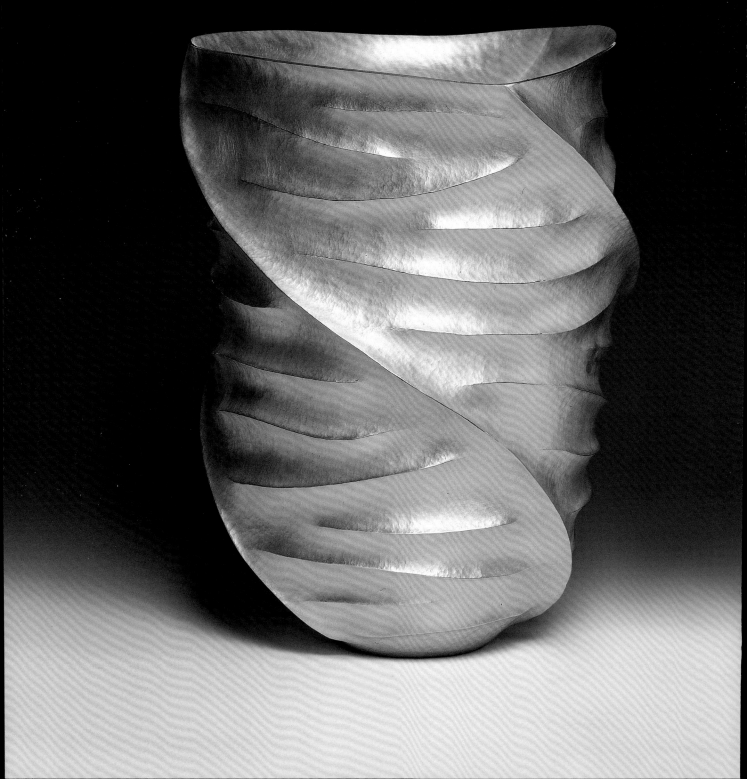

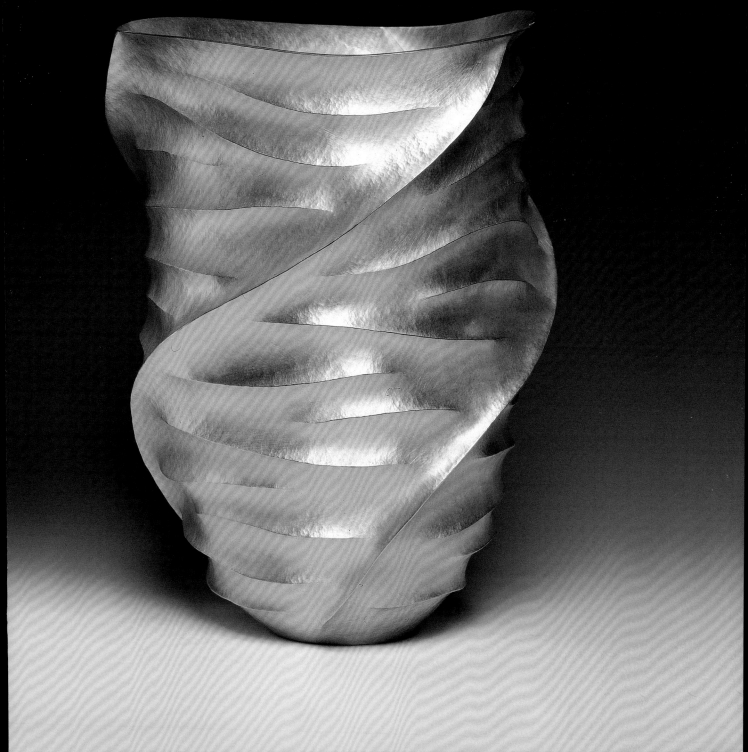

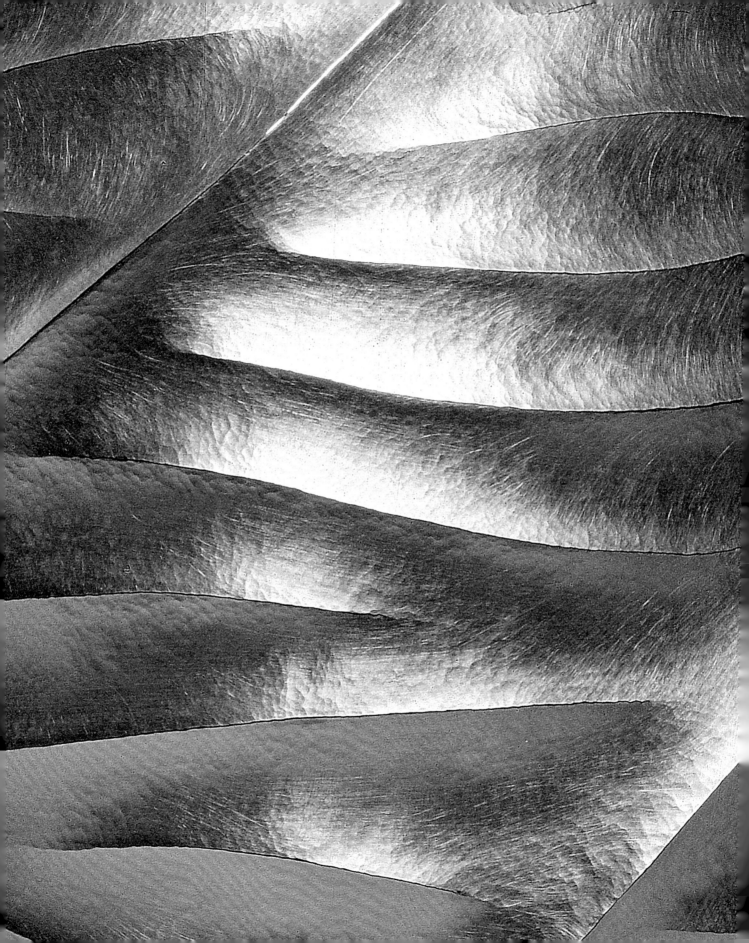

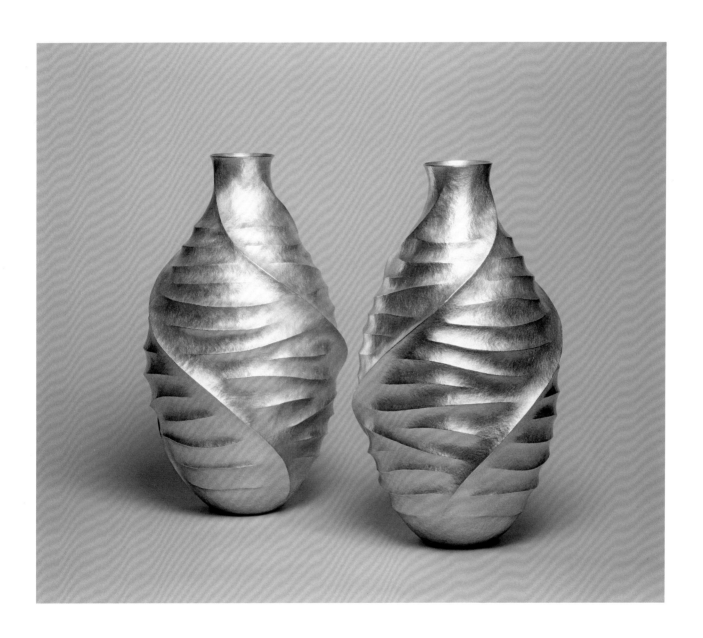

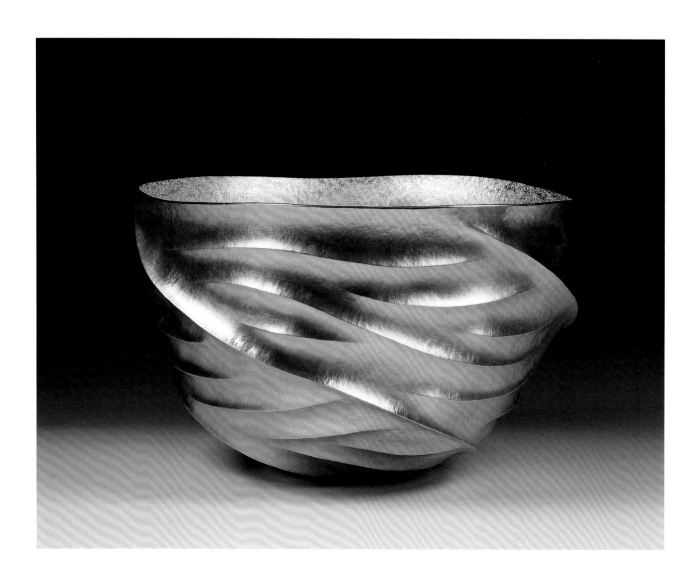

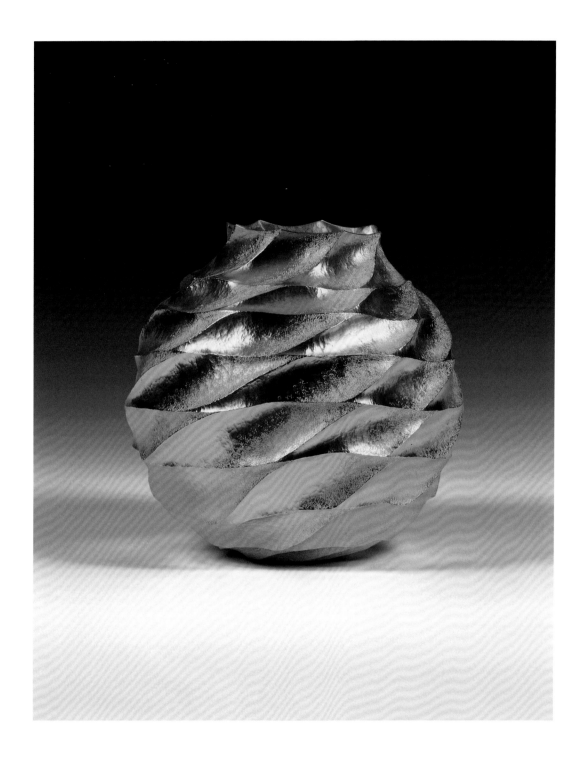

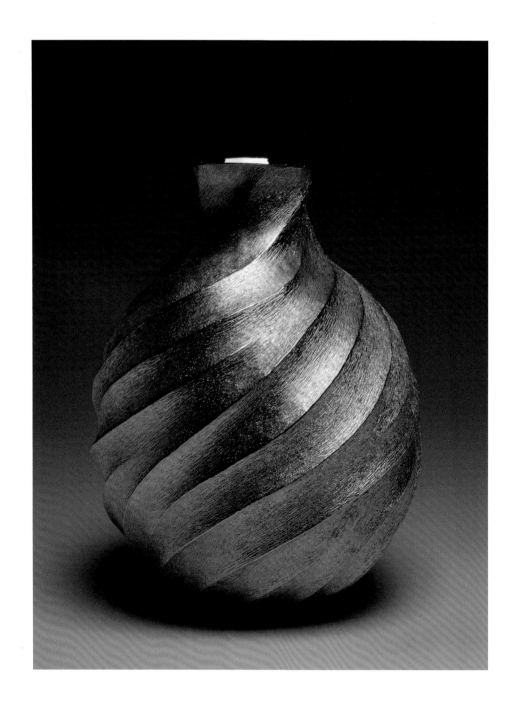

Air

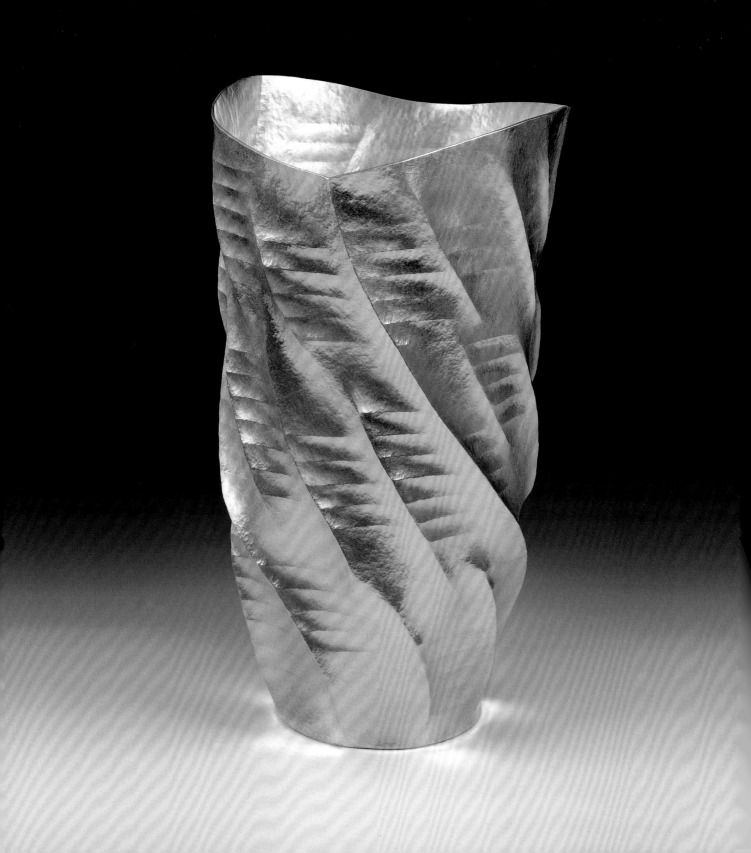

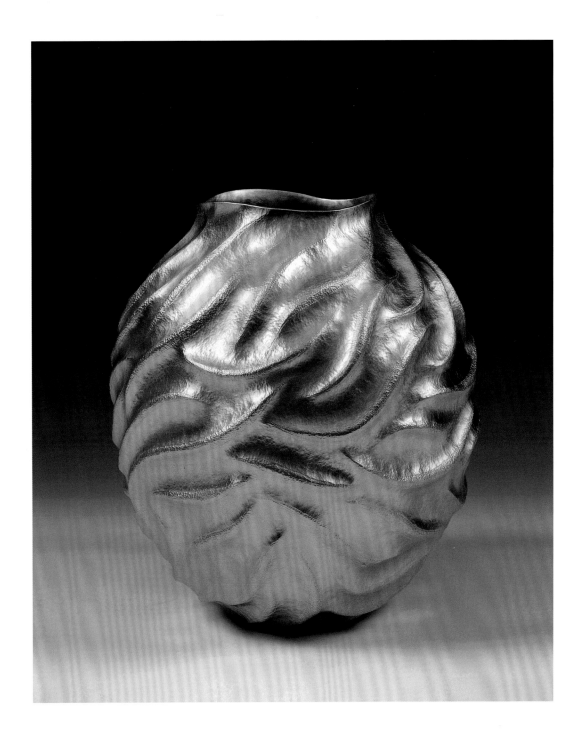

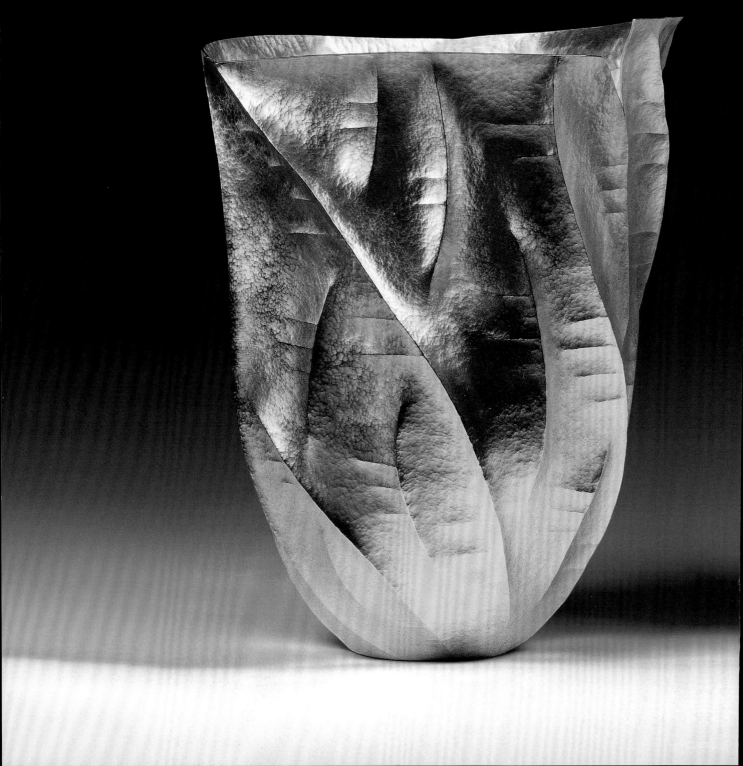

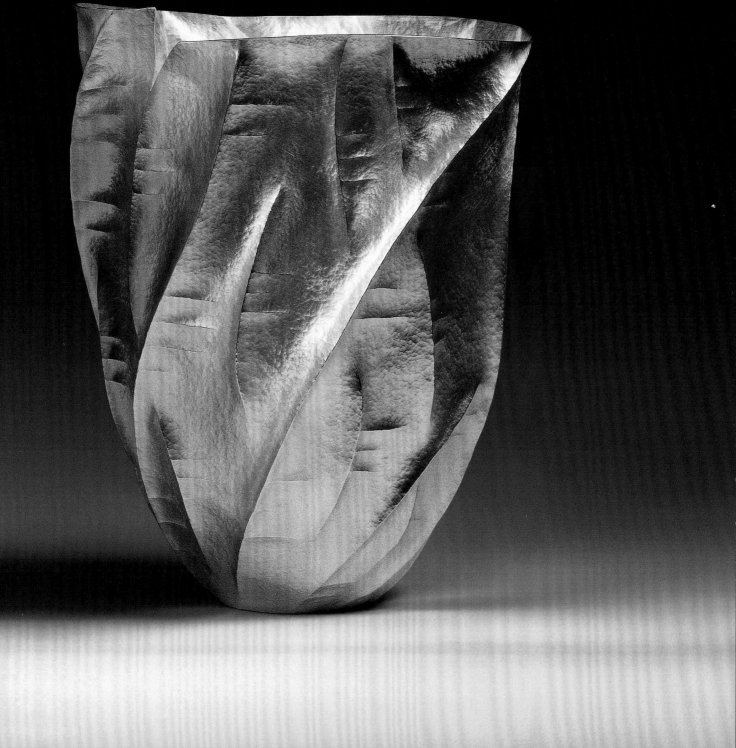

Fire

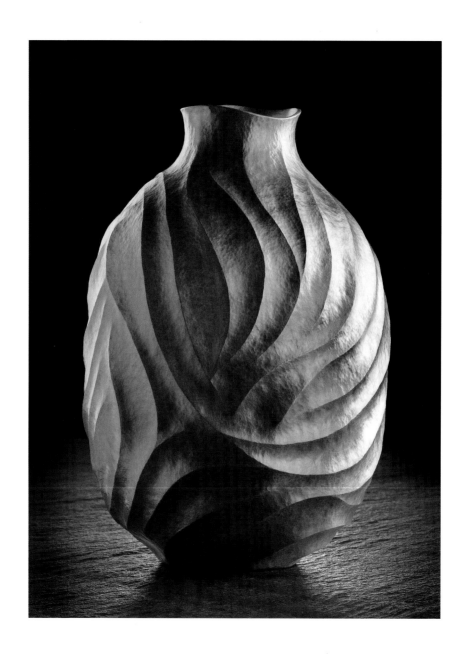

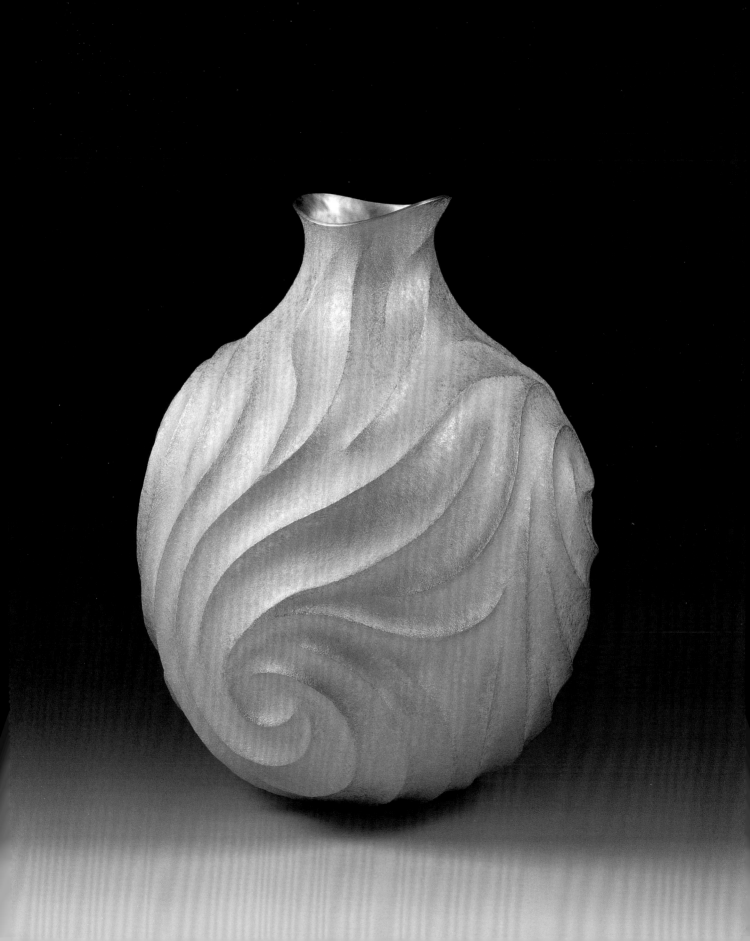

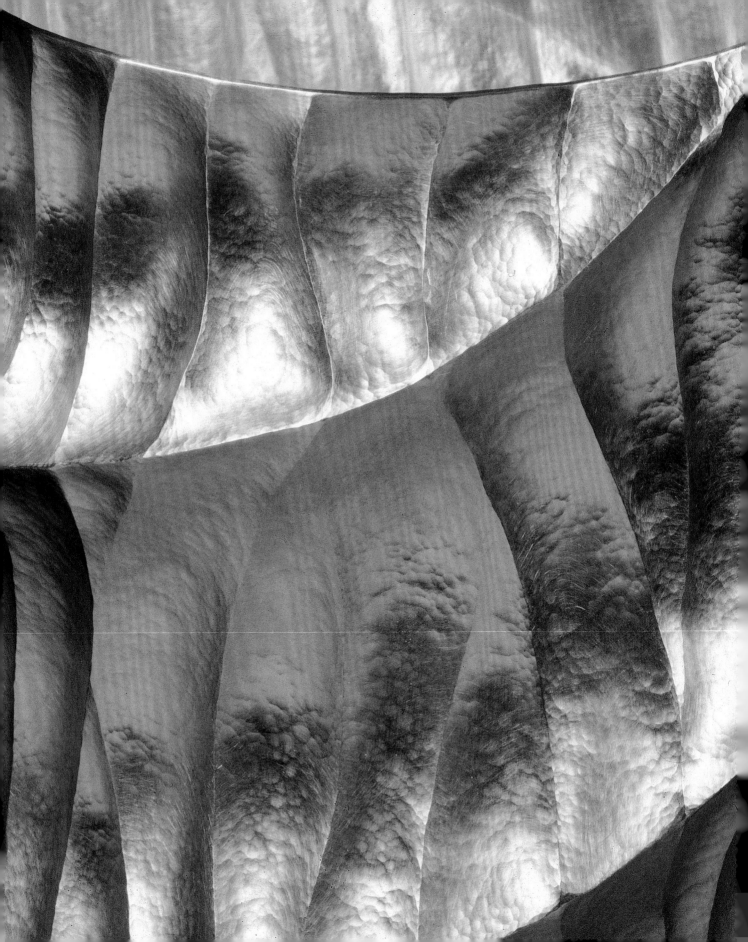

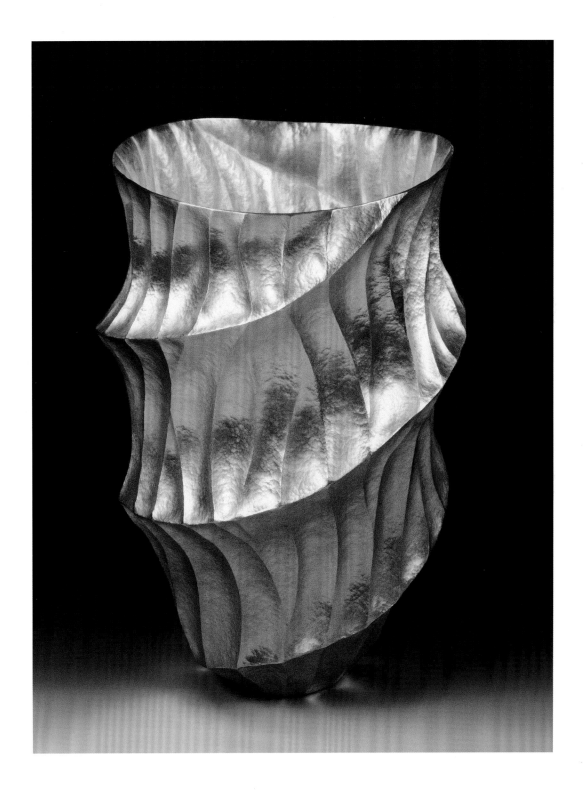

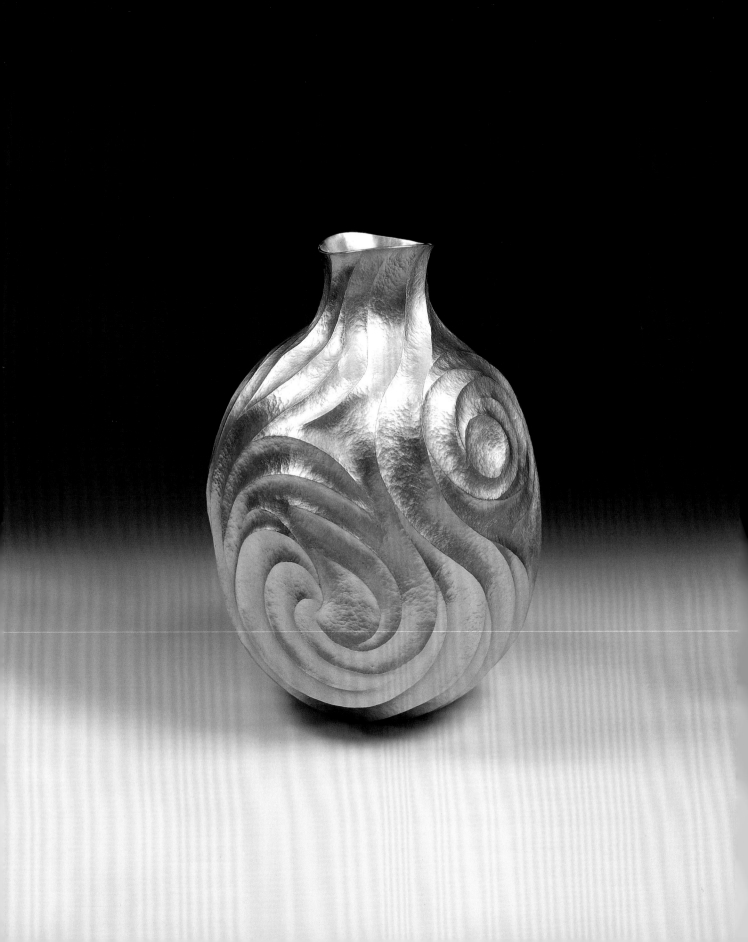

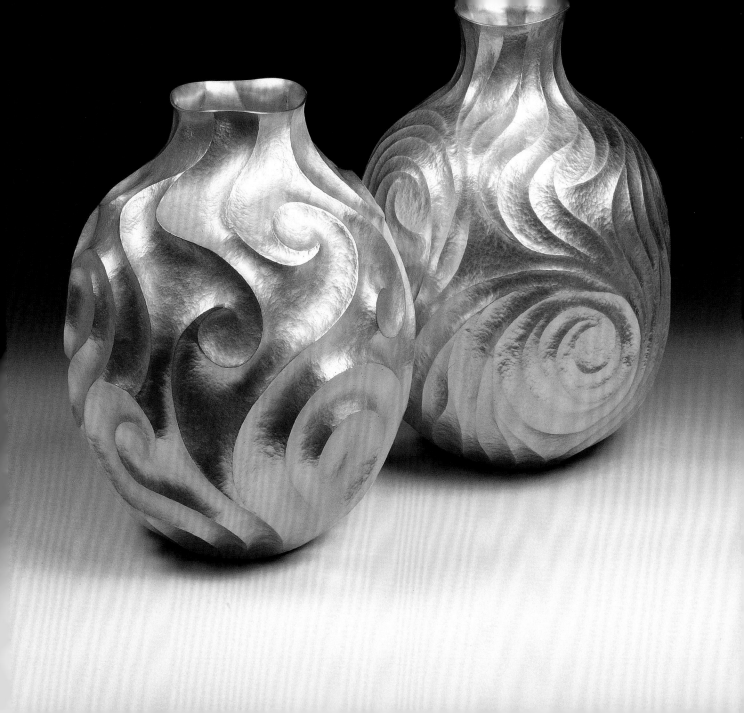

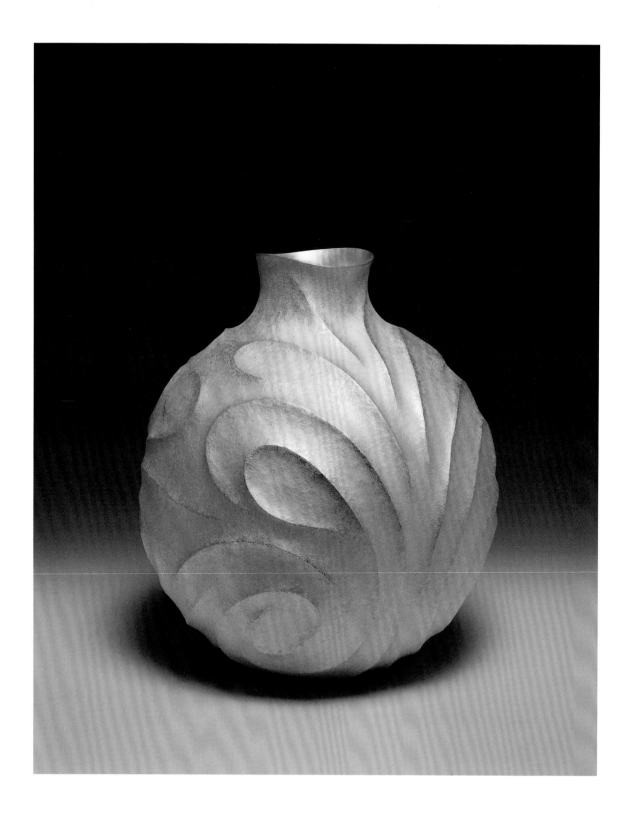

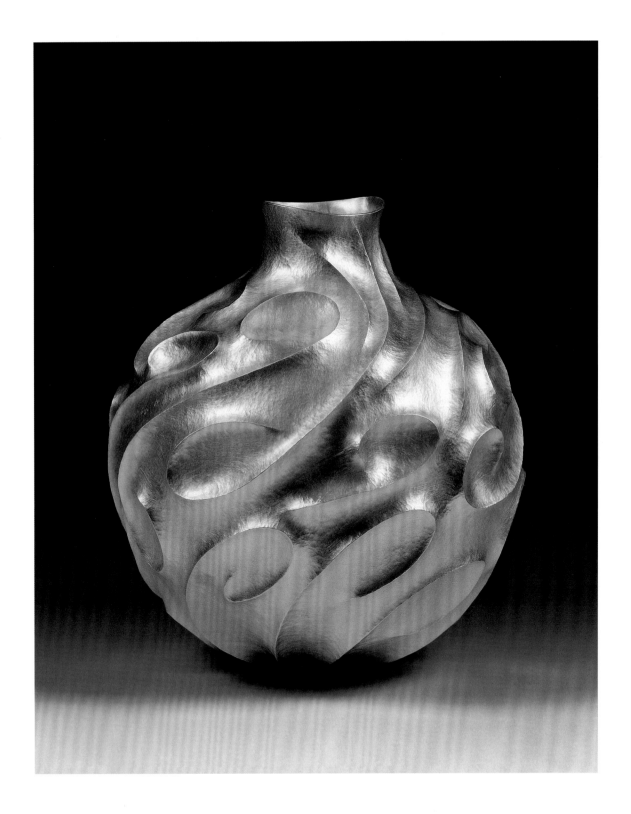

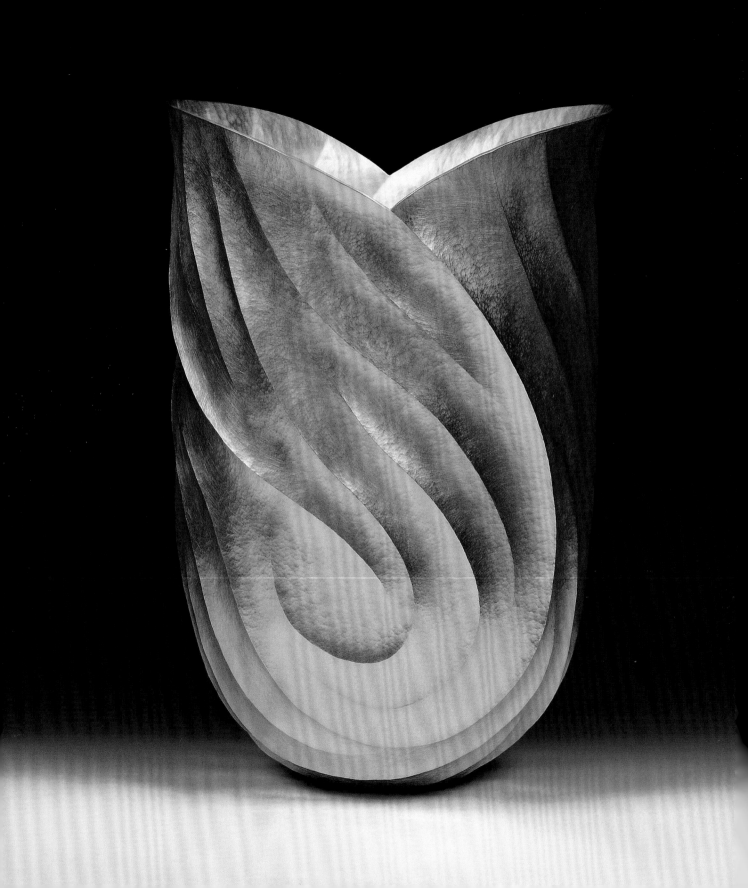

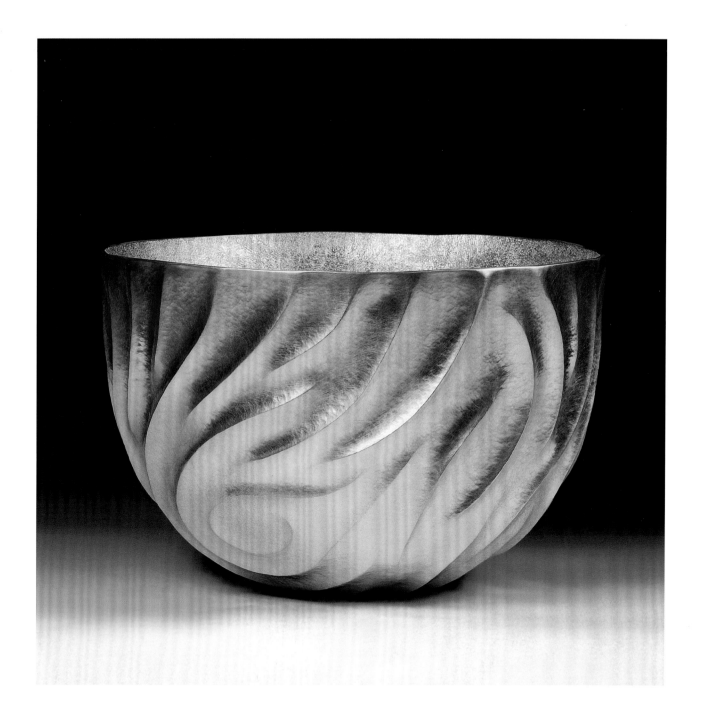

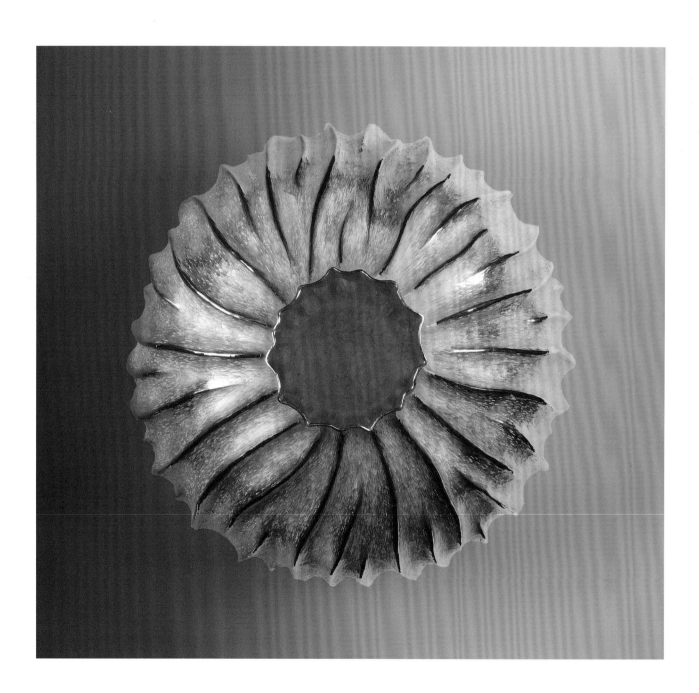

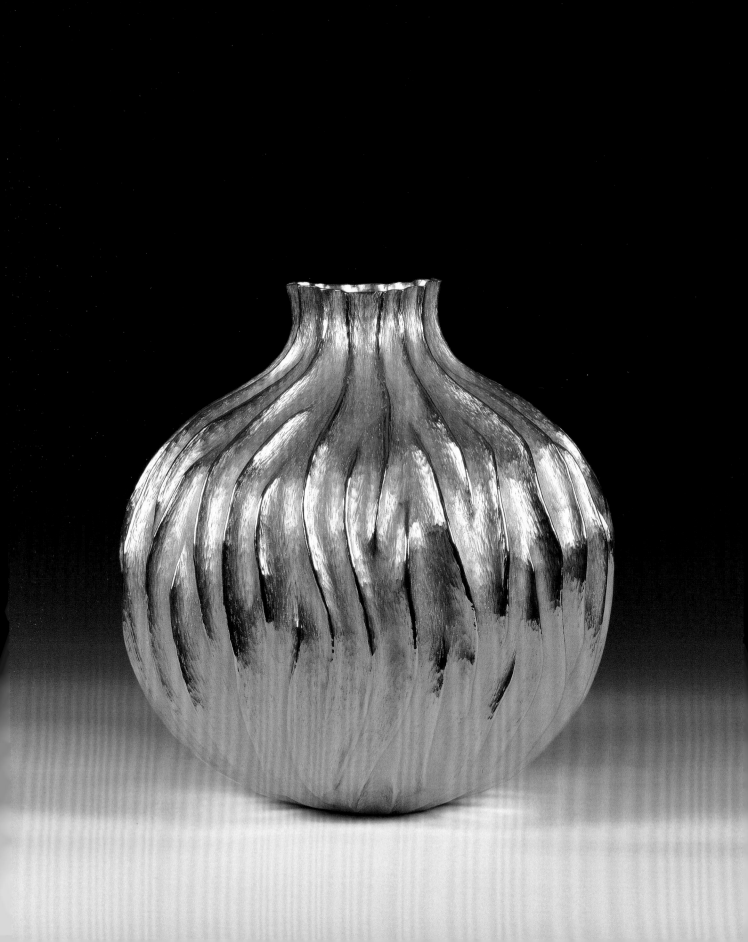

Earth

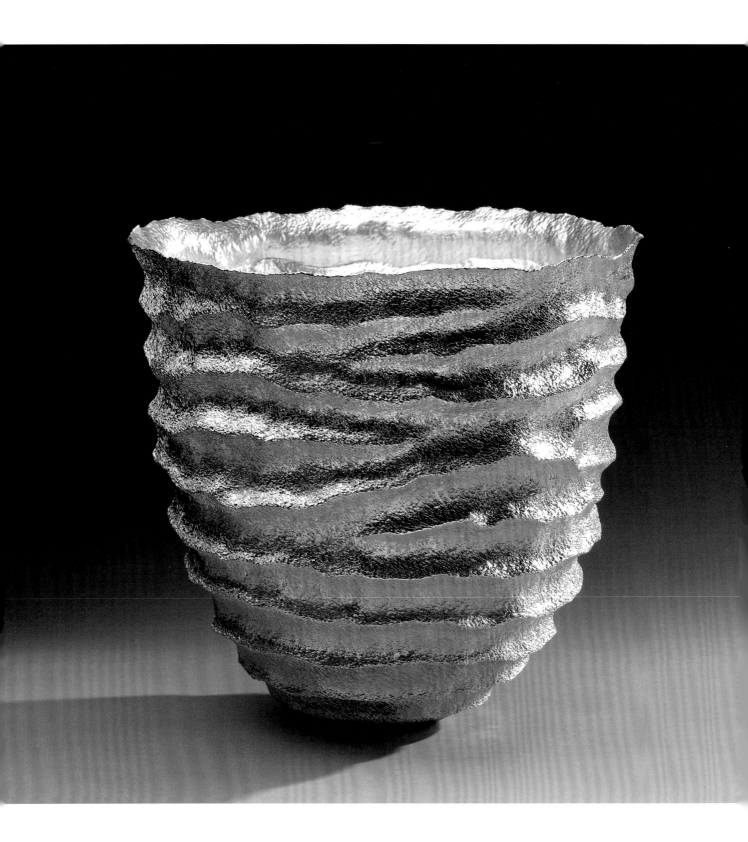

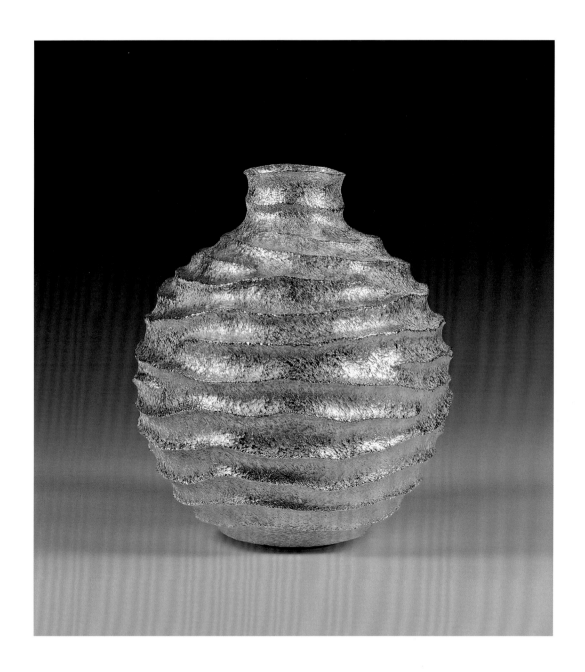

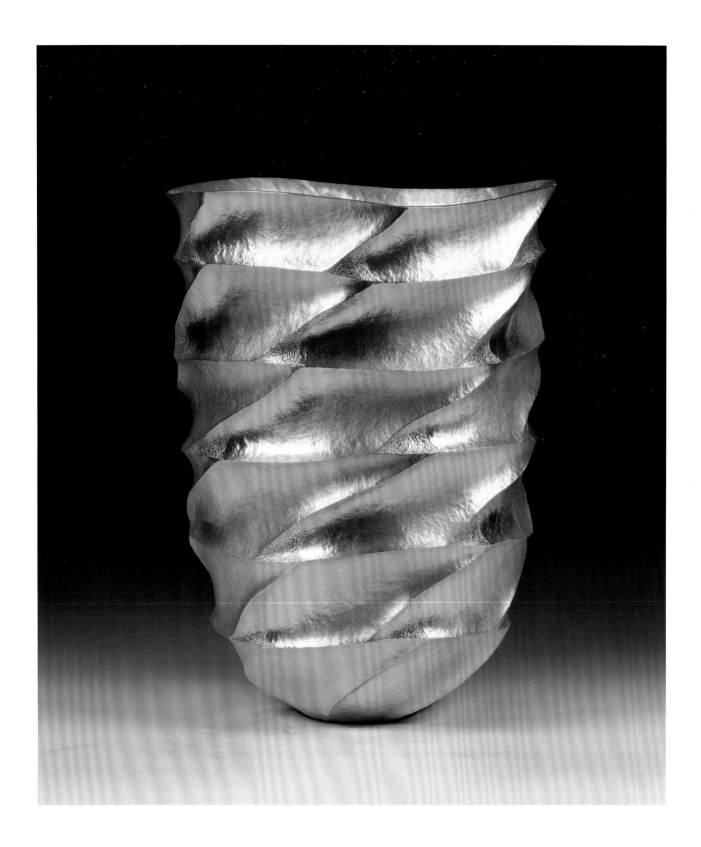

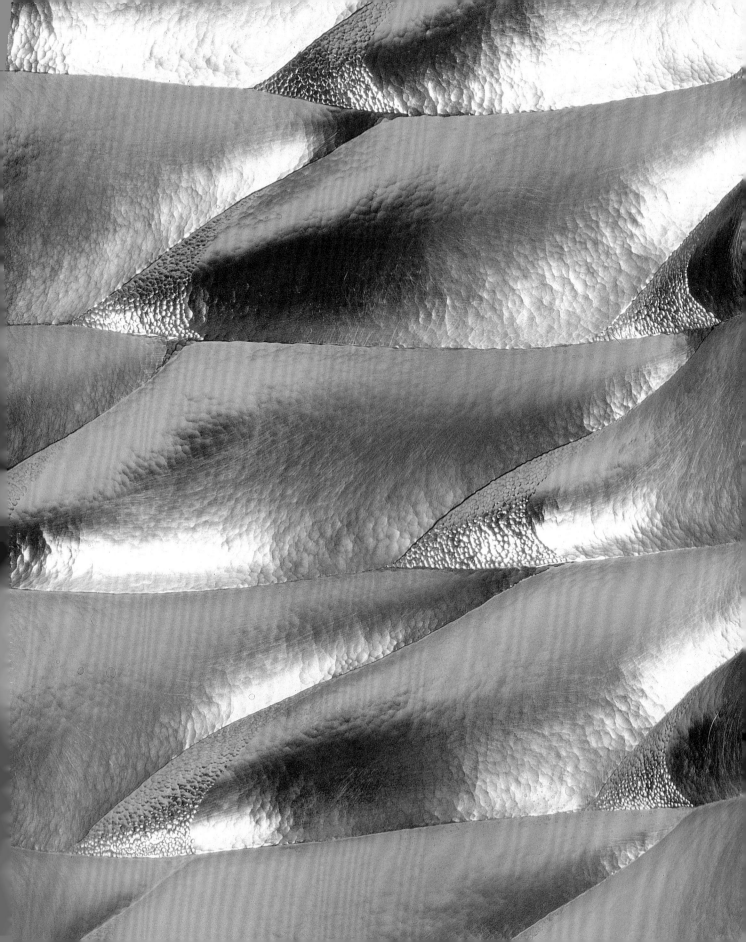

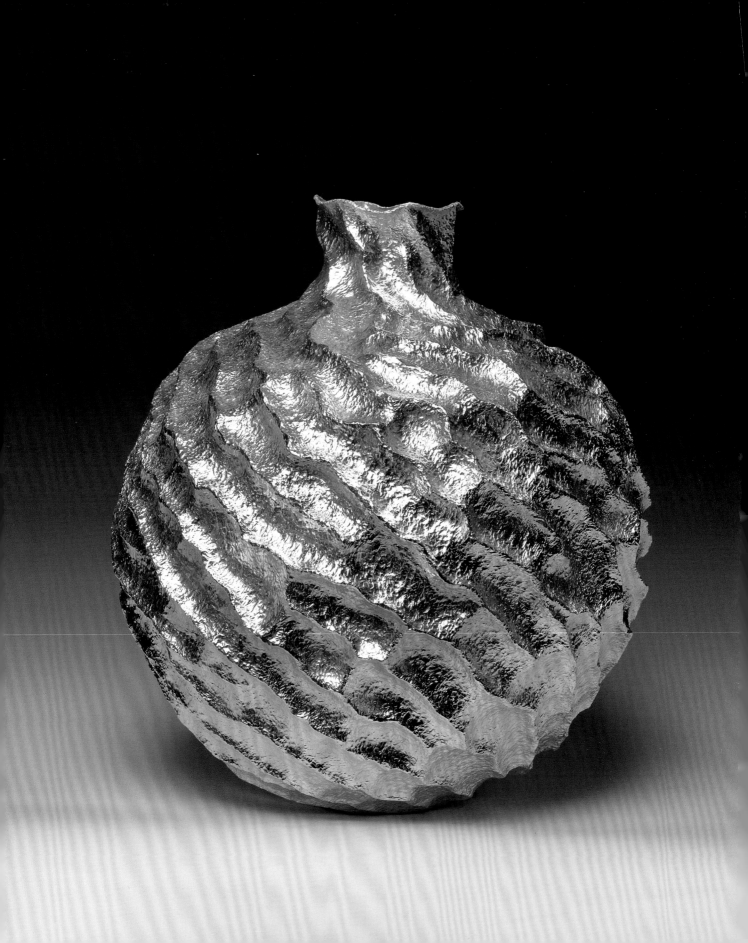

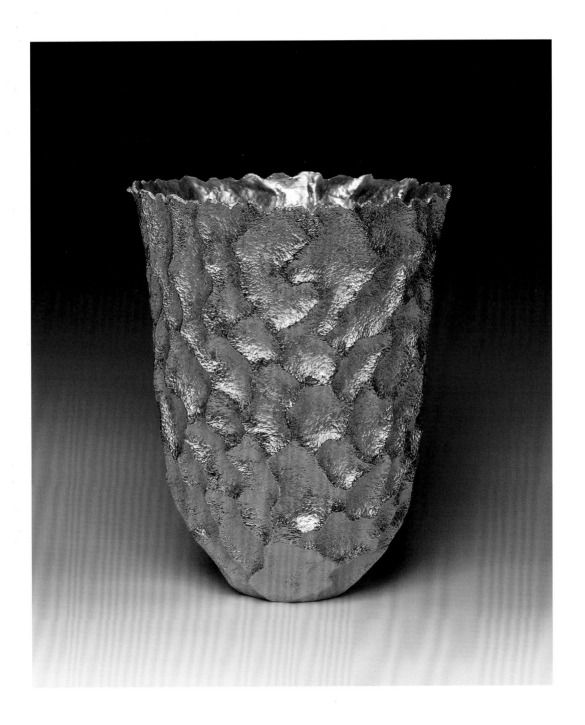

Hiroshi Suzuki

1961
Born, Sendai, Miyagi, Japan

1982–86
Musashino Art University, Tokyo, Japan, BA Industrial, Interior and Craft Design

1986–88
Musashino Art University, Tokyo, Japan, MA Industrial, Interior and Craft Design

1994–97
Camberwell College of Arts, London, UK, BA Silversmithing and Metalwork

1997–99
Royal College of Art, London, UK, MA Goldsmithing, Silversmithing, Metalwork and Jewellery

2009–present
Musashino Art University, Tokyo, Japan, Professor of Metalwork and Jewellery

Solo Exhibitions

2010
Hiroshi Suzuki – Silver Waves, retrospective, Goldsmiths' Hall, London, UK

2007
Hiroshi Suzuki, The Scottish Gallery, Edinburgh, UK, in association with Adrian Sassoon

2004
Hiroshi Suzuki, The Scottish Gallery, Edinburgh, UK
Hiroshi Suzuki, Studio 925, Schoonhoven, The Netherlands

2003
Statis in Motion, Lesley Craze Gallery, London, UK

1992
Mirage, Kochi Art Gallery, Tokyo, Japan
Labyrinth II, Ginza Komatsu Department Store, Tokyo, Japan

1991
Metamorphosis, Maki Art Gallery, Tokyo, Japan

1990
Illusion-Kaze, Tamura Art Gallery, Tokyo, Japan
Labyrinth, Gallery (NW House), Tokyo, Japan

Selected Group Exhibitions

2009
Adrian Sassoon, Pavilion of Art&Design, London, UK
Contemporary Silver, The Bishopsland Fellowship 1979–2009, Victoria and Albert Museum, London, UK
Clare Beck at Adrian Sassoon, COLLECT, The Saatchi Gallery, London, UK
Clare Beck at Adrian Sassoon, SOFA, New York, USA
Poetry in Silver, SilverArt Foundation, Bij de Watertoren, Schoonhoven, The Netherlands and tour
Adrian Sassoon, TEFAF, Maastricht, The Netherlands
Adrian Sassoon, London Art Fair, Business Design Centre, London, UK

2008
Adrian Sassoon, DesignArt London, UK
A Japanese Dialogue, The Scottish Gallery, Edinburgh, UK
Clare Beck at Adrian Sassoon, SOFA, New York, USA
Adrian Sassoon, TEFAF, Maastricht, The Netherlands
Clare Beck at Adrian Sassoon, COLLECT, Victoria and Albert Museum, London, UK

Adrian Sassoon, London Art Fair, Business Design Centre, London, UK

2007
Showcase Exhibition at Kunst und Handwerk Messe 07, Museum für Kunst und Gewerbe, Hamburg, Germany
Adrian Sassoon, The International Art + Design Fair, New York, USA
Land of the Samurai, Aberdeen Art Gallery & Museums, UK
Clare Beck at Adrian Sassoon, SOFA, New York, USA
Clare Beck at Adrian Sassoon, COLLECT, Victoria and Albert Museum, London, UK
Adrian Sassoon, London Art Fair, Business Design Centre, London, UK

2006
Dimensions – Large Vessels, Galerie Handwerk, Munich, Germany
Adrian Sassoon, The International Art + Design Fair, New York, USA
Clare Beck at Adrian Sassoon, SOFA, New York, USA
Master of Modern, EXEMPLA, Handwerkskammer für München und Oberbayern, Munich, Germany
Clare Beck at Adrian Sassoon, COLLECT, Victoria and Albert Museum, London, UK
Adrian Sassoon, London Art Fair, Business Design Centre, London, UK

2005
Contemporary Silver & Metalwork, G-H Modern, Grey-Harris & Co., Bristol, UK, in association with Adrian Sassoon
The Watkins Era, Contemporary Applied Arts, London, UK
Adrian Sassoon, The International Art + Design Fair, New York, USA
Jerwood Applied Arts Prize 2005: Metal, Crafts Council, London and UK tour
Modern Pots from the Lisa Sainsbury Collection, Dulwich Picture Gallery, London, UK

The Universe of Metals, EXEMPLA,
 Handwerkskammer für München und
 Oberbayern, Munich, Germany
Clare Beck at Adrian Sassoon, COLLECT,
 Victoria and Albert Museum, London,
 UK

2004
Adrian Sassoon, The International Art +
 Design Fair, New York, USA
Treasures of Today, The Harley Gallery,
 Welbeck, Nottinghamshire, UK
Creation, Goldsmiths' Hall, London, UK
Graft, The Harley Gallery, Welbeck,
 Nottinghamshire, UK
Adrian Sassoon, London Art Fair, Business
 Design Centre, London, UK

2003
Clare Beck at Adrian Sassoon, SOFA,
 Chicago, USA
Adrian Sassoon, The International Art +
 Design Fair, New York, USA
Silver Sparks, The Bishopsland Connection,
 Gilbert Collection, London, UK
Celebration in Gold and Silver, Goldsmiths'
 Hall, London, UK
Silver Lives!, Gilbert Collection, London,
 UK

2002
*Innovation and Design, Silver from
 Goldsmiths' Hall, London 1900–2001*,
 Museet på Koldinghus, Kolding,
 Denmark

2001
The Unexpected, Sotheby's, New York,
 USA
Raised Forms, The Pearoom, Heckington
 and The Surrey Institute of Art & Design,
 Farnham, UK
Wabi Sabi, Contemporary Applied Arts,
 London, UK
Cultural Exchange: Japan 2001, Birmingham
 Museum and Art Gallery, UK
Ripple, Ropewalk Contemporary Art &
 Craft, Barton-on-Humber, UK
Contemporary Decorative Arts, Sotheby's,
 London, UK

2000
Contemporary Silver & Metalwork,
 New Ashgate Gallery, Surrey, UK

The Young Silversmiths Exhibition,
 The Scottish Gallery, Edinburgh, UK
A Feast of Silver, Contemporary Applied
 Arts, London, UK

1999
Simplicity and Elegance, Katie Jones Gallery,
 London, UK
Cheongju International Craft Biennale,
 Cheongju City Art Hall, Cheongju
 City, Chungbuk, South Korea
Contemporary Decorative Arts, Sotheby's,
 London, UK
Decade, Villa De Bondt, Ghent, Belgium
A Century in the Making, The London
 Institute Gallery, London, UK
Metalmorphosis, Museum of Decorative
 Arts, Prague, Czech Republic, and
 Bröhan Museum, Berlin, Germany

Awards

2009
Winner, *Poetry in Silver*, Schoonhoven
 Silver Award 2009, SilverArt Foundation,
 Schoonhoven, The Netherlands

2006
The Bavarian State Prize, EXEMPLA,
 Munich, Germany

2005
Shortlist, Jerwood Applied Arts Prize 2005:
 Metal, Jerwood Foundation, London, UK

1999
Grand Prize, Cheongju International
 Craft Competition, Cheongju City,
 Chungbuk, South Korea
Commission, P&O Makower Trust for
 Victoria and Albert Museum, London,
 UK
Commendation, The Goldsmiths'
 Craftsmanship & Design Awards,
 London, UK

1989
Honorable mention, Kohdo Sculpture
 Competition, Tokyo, Japan

1986
Winner, Musashino Art University
 Graduation Awards, Tokyo, Japan

Public Collections

Aberdeen Art Gallery & Museums, UK
Birmingham Museum and Art Gallery, UK
Bristol City Museum & Art Gallery, UK
The Clothworkers' Company, London, UK
Crafts Council, London, UK
The Fitzwilliam Museum, Cambridge, UK
Museums Sheffield: Millennium Gallery,
 UK
The National Museum of Wales, Cardiff,
 UK
National Museums Liverpool, UK
National Museums of Scotland, Edinburgh,
 UK
New College, University of Oxford, UK
P&O Makower Trust, London, UK
Royal College of Art, London, UK
Sainsbury Centre for Visual Arts, Norwich,
 UK
The Salters' Company, London, UK
Shipley Art Gallery, Gateshead, UK
Ulster Museum, Belfast, Northern Ireland,
 UK
University of the Arts, London, UK
Victoria and Albert Museum, London, UK
The Worshipful Company of Goldsmiths,
 London, UK
The Worshipful Company of Grocers,
 London, UK

Farmleigh House, Dublin, Ireland
Musée Mandet, Riom, France
Museum für Kunst und Gewerbe,
 Hamburg, Germany

Museum of Arts and Design, New York,
 USA
The Museum of Fine Arts, Houston,
 Texas, USA

Art Gallery of South Australia, Adelaide,
 Australia
Cheongju National Museum, Chungbuk,
 South Korea

Published to coincide with the exhibition

Hiroshi Suzuki – Silver Waves
8 February – 6 March 2010
Goldsmiths' Hall
Foster Lane
London EC2V 6BN

Front cover
Aqua-Poesy VII, 2009
Hammer-raised and chased Fine silver 999
H 31 cm (12¼") Ø 28 cm (11")
Private Collection

Front cover flap
Dual-Rivulet III, 2000
Hammer-raised, double-skinned
Britannia silver 958
H 15 cm (5⅞") Ø 26.5 cm (10⅜")
Devonshire Collection, Chatsworth, Derbyshire, UK
Reproduced by permission of Chatsworth Settlement
Trustees

Page 2
Hiroshi Suzuki working in his studio
at the Harley Foundation, Welbeck
Estate, Nottinghamshire

Page 13
A private collection of Hiroshi Suzuki
silver vases, New York, USA

Back cover
Detail of *Aqua-Poesy II*, 2006
Hammer-raised Fine silver 999
H 32 cm (12⅝") Ø 21 cm (8¼")
Private Collection, USA

© Scala Publishers Ltd, 2010
Text © Adrian Sassoon, 2010
Essay © Timothy Schroder, 2010
Photography © Adrian Sassoon, 2010

First published in 2010 by
Scala Publishers Ltd
Northburgh House
10 Northburgh Street
London EC1V 0AT
Tel: +44 (0)20 7490 9900
www.scalapublishers.com

ISBN-13: 978-1-85759-625-0

Project editors: Kathleen Slater (Adrian
Sassoon) and Esme West (Scala)
Copy editor: Rosalind Neely
Design: Fraser Muggeridge studio
Photography: Matthew Hollow and
Rob Glastra, Erik Kvalsvik, Johnny
Magee, R&R Studios

Printed and bound in Italy

10 9 8 7 6 5 4 3 2 1

British Library Cataloguing in
Publication Data
A catalogue record for this book is
available from the British Library.

Hiroshi Suzuki would like to thank:

Laura Baxter
Clare Beck
The Duke of Devonshire
Lisa Gee
Alex Hallowes
Professor Yasuki Hiramatsu
Aya Iwata
Professor Rikio Koizumi
William Sang-Hyeob Lee
Penelope & Oliver Makower
Simon Mount
William Odell
Alison & William Parente
Mark Piolet
Rosemary Ransome Wallis
Pete Rogers
Adrian Sassoon
Timothy Schroder
Kathleen Slater
Goro Tezeni
Andrew Wicks

Adrian Sassoon would like to thank:

Paul Dyson
Rupert Hambro
Hancocks & Co. Ltd.
Mark Pollack
Brigitte Saby
The Scottish Gallery
Amanda Stücklin
Felicity Winkley